PHILOSOPHY

OF

ART EDUCATION

EDMUND BURKE FELDMAN
The University of Georgia

Prentice Hall
Upper Saddle River, New Jersey 07458

Library of Congress Cataloging-in-Publication Data

Feldman, Edmund Burke.
 Philosophy of art education / Edmund Burke Feldman.
 p. cm.
 ISBN 0-13-230830-4 (casebound)
 1. Art—Study and teaching. 2. Art—Philosophy. I. Title.
N84.F46 1996
707—dc20

95-15160
CIP

Acquisitions editor: *Norwell Therien*
Editorial assistant: *Lee Mamunes*
Production editor: *Jean Lapidus*
Copy editor: *Maria Caruso*
Indexer: *Maria Caruso*
Cover designer: *Bruce Kenselaar*
Manufacturing buyer: *Robert Anderson*

Printed in the United States of America
10 9 8 7 6 5 4 3 2 1

ISBN 0-13-230830-4

Prentice-Hall International (UK) Limited,London
Prentice-Hall of Australia Pty. Limited, Sydney
Prentice-Hall Canada Inc., Toronto
Prentice-Hall Hispanoamericana, S.A., Mexico
Prentice-Hall of India Private Limited, New Delhi
Prentice-Hall of Japan, Inc., Tokyo
Pearson Education Asia Pte. Ltd., Singapore
Editora Prentice-Hall do Brasil, Ltda., Rio de Janeiro

CONTENTS

CONTENTS

PREFACE

I have taught art in a strange assortment of places—usually because I needed the money and there was nothing else I could do. While serving in the Philippines I taught oil painting to an old Chinese merchant in San Francisco del Monte, near Manila. Later I taught life drawing in a proprietary art school in Wilkes Barre, Pennsylvania; it was operated by a high-school art teacher for World War II veterans who were collecting government checks and didn't really care about art or art teachers. That was how I learned about student recalcitrance. I quit the job before I was fired.

For a short time I taught inner-city kids in a neighborhood center near Columbia University. They didn't like my teaching either; I quickly gave up on that job. I had a more successful experience teaching art appreciation at the YWCA in New York City; at least they asked me to come back. Then a plastic surgeon in New Jersey hired me to teach him drawing two nights a week; it made me feel important to teach a real doctor. While professing art in Pittsburgh, I taught evening classes in drawing and painting to senior citizens at the YM and YWHA; they taught me more than I taught them. In Livingston, Alabama I gave private drawing lessons to Ms. Ruby Tartt, a beautiful elderly woman who had studied with William Chase in New York; she introduced me to pecan pie, which I have loved ever since. Also

in Livingston I taught portrait painting in the back room of an antiques shop. The facilities were poor but the atmosphere was stimulating: I get my color sense from antiques.

There were many other jobs and visiting teaching stints—most of them gratifying and a few of them too embarrassing to talk about. Still, they had value: I learned what not to do and what I could get away with. The point of this picaresque tale is that I taught art in a variety of settings before attempting to philosophize about art education. I realize, of course, that art education is larger than mere art teaching, but I cling to the antiquated notion that they are somehow related. In this book I attempt to integrate both subjects.

Now let me express my gratitude for the privilege of putting these thoughts into print, and for letting me call them philosophy. I appreciate especially the encouragement of my publisher at Prentice Hall, Norwell F. (Bud) Therien, plus the help of all the other professionals who have seen this project through to the end. Let me also thank Virginia Seaquist for her patience in preparing the manuscript. Needless to say, none of these good folk should be held responsible for the errors—pedagogical, aesthetical, and metaphysical—that have crept into the text. Finally, I must thank my teachers and students; they instructed me in philosophy by raising the questions this book tries to answer.

<div style="text-align: right;">Edmund Burke Feldman</div>

INTRODUCTION

The structure of art education can be compared to early Romanesque church architecture. The medieval masons knew the value of improvisation; they borrowed, they adapted, and they lumped-together. Beginning with a Roman floor plan, they added a Greek porch, Syrian domes, Byzantine mosaics, Celtic spirals, and Muslim prayer towers. With these exotic elements they created a magnificent architectural hodgepodge; many of us prefer it to the more refined and systematic Gothic. We like the Romanesque style, I think, because all its borrowings and improvisations have produced a curiously organic whole—a unity that works aesthetically.

Perhaps the same is true of the peculiar collection of ideas, teaching practices, and curricular schemes called *art education*. We are attached to that discipline by habit and sentiment, but we would not want to defend it as great architectural engineering. Nor do we want to see that educational edifice collapse—not while our students and colleagues are in it. Which suggests that the structure of our discipline needs examination with a view toward finding out what holds it together and what makes some of it, at least, worth keeping.

Before launching into the *philosophy* of our profession, it might be wise to define it as a discipline. Some thinkers would not confer that status

1

on art education, holding that it is a hybrid subject, an amalgam of older, truly legitimate disciplines such as educational psychology, history of art, aesthetics, the social sciences, and an assortment of studio activities. Without denying the partial truth of that charge, we might observe that (1) most modern disciplines (especially the social sciences) began as the illegitimate offspring of respectable academic parents; and (2) combined disciplines often enjoy an advantage biologists call "hybrid vigor." Which is to say that art education is alive and kicking today because it represents a successful response to needs that traditional disciplines failed to meet.

Examining art teaching more closely, we can see that it includes everything from instruction in the usual studio subjects to engaging in high-flown talk about creativity, Dewey's concept of "an experience," Danto's notion of an "artworld," and the wisdom of using Mapplethorpe's photographs as grade-school teaching materials. No matter what you think of these ideas and activities, they testify to the extraordinary range and vigor of our profession. They also suggest that if we have a discipline it could use some definitive rigor.

Let me offer the following definition of our discipline. Art education is an enterprise that encompasses teaching and learning to make and understand art, as well as finding out about the world and ourselves through art. Here we should stipulate that by "art" we mean *visual* art—everything from traditional painting, sculpture, and architecture, to the crafts, industrial design, photography, cinema, television, and computer art. Accordingly, our discipline studies the form and function of every kind of object created by our species, every way we have devised to make and transmit images, plus the impact of those objects and images on all kinds of people and environments. Finally, art education embraces the various modes of discourse employed in making art, studying the history and anthropology of art, discerning the meanings of art, and assessing the value of individual works of art.

Given its inclusiveness, this definition would seem to have all the elegance and exactitude of a kudzu vine. But there is no way to shorten it without ignoring what art educators do, or preventing them from doing what they ought to do. In self-defense we might appeal to the power, if not the precision, of Romanesque architecture.

What would a philosophy of art education be and what good would it do? First, it would be a statement of the basic beliefs of art teachers as they practice their profession. Second, it would offer a critique of the means through which teachers implement those beliefs. Third, it would be a statement of the ideal goals toward which the best efforts of art educators ought to be directed.

Now what would be the value of such a philosophy? I think it would help us decide whether our beliefs are solidly grounded. It would help us to know whether our methods and strategies are likely to succeed. And it

would tell us when we are doing the right or wrong things for the right or wrong reasons.

Notice that the philosophy of art has not been mentioned. Does it have any bearing on the subject of this book? Yes, insofar as it informs our understanding of art and offers propositions about the value of art in history, in society, and in the life good to live. But "no" insofar as philosophy does not tell us whether, when, or how the values of art are realized through teaching.

What about the philosophy of education? Again, it bears on our subject insofar as it offers propositions about the purposes of schooling in a democracy, about the learning value of nonacademic modes of study, and about the role of creativity in institutions committed to prescribed outcomes. However, the philosophy of education cannot tell us how a certain art-teaching practice hurts or hinders what we are trying to accomplish. And that is because it cannot tell us—from the inside, so to speak—what it feels like to get in or out of trouble when making an image, or trying to understand an image that someone else has made.

Clearly, a unique type of experience is required to *recognize the problems posed* when philosophy encounters a complex activity conducted by specially trained persons, working in varied institutions, serving populations that have a multiplicity of needs. To cope with these problems we should try to find connections between the diverse visual arts, the principal modes of classroom instruction, the different types of learning, the changing needs of society, and the ideal goals we seek. Which means that our language of theory and generalization should seek the level of educational practice.[1] If not, it could become a kind of aesthetic object—something to be admired but, alas, not used.

Now imagine a philosophy of art education that emphasizes the value of drawing as a way of promoting psychological health and mental growth. Well, we need to realize that there are important ways of drawing that contribute practically nothing to an artist's or student's psychological health.

Imagine another philosophy that stresses the value of art as a way of understanding distant lands and peoples. Well, understanding is no guarantee of appreciation or approval. We might study the art of distant lands and peoples and learn to dislike them very much—a regrettable but nevertheless possible result.

Imagine a philosophy that maintains that artistic activity promotes nonconformity and willingness to take risks. Well, there are valid artistic approaches that place a premium on careful following of formulas, close adherence to tradition, and reluctance to take risks.

1 On this point Aristotle offers some good advice: "Intellect in itself, however, has no power to move; it must be directed to a certain end; in other words, it must be practical." (See Aristotle. *Nicomachean Ethics*, Book VI, Chapter 2.)

What these hypotheticals demonstrate is the difficulty of making global assertions about art teaching and learning. Drawing may indeed promote psychological health, but not always nor for everyone. For example, we could teach a third grader to draw telephone poles in single-point perspective without significantly affecting that child's psychological development or powers of self-expression. We could study Rubens's hunting scenes and find ourselves repulsed by the sight of noble Flemish horsemen butchering innocent wild animals. We could teach children to make fearsome papier-mâché masks, only to discover that it gives some of them nightmares.

Apart from illustrating the law of unintended consequences, these examples urge us to be cautious about building a total philosophy on a single foundation or premise. Which is to say, "If all you have is a hammer, all your problems begin to look like nails." Strict monism and single-minded principles produce very predictable results. This has led me to advocate a *multidimensional philosophy* of art education. When it comes to understanding and justifying our still-growing discipline, several grounds are better than one.

Accordingly, this book offers extended discussions of five major departments of human thought and action as they impinge upon art teaching and learning. I call them the *social dimension,* the *economic dimension,* the *political dimension,* the *psychological dimension,* and the *cognitive/moral dimension.* Other dimensions could be cited, of course, but we need not multiply categories here: with a five-dimensional net we should be able to catch plenty of fish.

REFERENCE

ARISTOTLE. *Nicomachean Ethics,* Book VI, Chapter 2. John E. C. Welldon (trans.). Buffalo, NY: Prometheus, 1987.

THE SOCIAL DIMENSION

INTRODUCTION

How are the lives of people in groups affected by the ways they make, use, or respond to art? How are these groups affected by the ways they learn about art? How does art education, broadly conceived, impinge on the behavior of people when they are gathered into families, associations, and institutions?

Our answers to these questions should acknowledge a defining trait of art: it is a mode of connecting, a form of communication. If art were only self-expression it would have a legitimate role in education, but that role would be very limited. We would have to think of students as atomized individuals whose relation to society and each other is usually self-centered and frequently unresponsive. The latter term is crucial: it alludes to the inability or reluctance of an individual to answer. Inability to answer means inability to communicate, which means inability to reach out and share the contents of one's self.

So we come full circle: self-expression in art means nothing if there are no other selves to hear (or see) what we are saying. Not only must there be other selves for genuine self-expression to take place; there must be

other selves who care about—because they are affected by—what our species makes, says, and does. A society needs to know how art has shaped its past, how it sees the present, and what it expects to see in the future.

Notwithstanding the fact that learning is ultimately a personal act, we cannot ignore the social character of the forces that set learning into motion. Art is one of those forces: it is a bridge between individuals and the communities in which they have their being. As for art education, it functions like the Pope, who is called *pontifex*, or bridge-builder. What follows is a discussion of some of the problems art education encounters as it goes about the business of building bridges—connections between persons, places, and peoples who depend on each other.

THE FAMILY GROUP

The family, of course, is our most important social institution although it has ceased to be an art-producing institution except in so-called "backward" or preindustrial economies. Children continue to learn crafts under family auspices, but modern industrial economies provide almost everything a family needs more quickly and at lower cost than it could be made at home.

Perhaps because of the time saved by modern industrialism, the family has become an essentially art-*consuming* institution. Without doubt, the main type of art consumed in the home consists of images delivered by television, magazine graphics, and direct-mail advertising. As for art used and displayed in the home, it is represented by framed pictures, photographs, furniture, sculptural lampbases, carpets, and assorted knick-knacks—mostly purchased in shopping malls. The costlier purchases change infrequently; they become part of the wallpaper, so to speak. The most aesthetically vivid and arresting items of home art are probably found in the kitchen, a veritable museum of our civilization's best household implements and appliances. These change regularly, but here it is mass marketing, not art education, that accounts for their high design quality, even in the humblest home.

Obviously, the focus of family life has shifted from economic production to mechanical efficiency, aesthetic consumption, and symbolic display. Has this shift been recognized in art education programs? Not really. The impact of product design on objects of daily use tends to be ignored in education at all levels. The crafts, on the other hand, continue to receive a large share of curricular space. Of course, the crafts represent important opportunities for learning about the connections between form, function, and materials. But we have not, for the most part, built on this learning by extending its principles to the study of the industrially produced objects

that support our economy, shape our environments, and give texture to our daily lives.

THE COMMUNITY

The child who lives in a housing project, a flat-roofed trailer, or a detached suburban dwelling, draws a house as a gabled cottage, resting on a base line, and dominated by an image of himself or herself as tall as the roof, accompanied by lollipop trees, shrubs, and lawn grass—all warmed by a radiant symbol of the sun. This virtually universal image represents the child's nascent idea of the community. You will concede that it is a remarkable achievement—the simultaneous expression of personal, architectural, and cosmic concepts to produce a world-image. That image, with its separation of earth from sky, its rudimentary ecological awareness, its notion of "outside" space, and its symbol of overall protection, constitutes a crucial rite of passage; it is a social coming-of-age. The child who draws this picture may not be ready to leave the family, but he or she has discovered being-in-the-world.

Soon there will be pictures of people doing things together—working, shopping, playing—in the world, in its communal space. Not all of the people shown are relatives: some are friends, neighbors, or schoolmates; a few are total strangers. This normal development in a child's picture-making activity corresponds, conceptually speaking, to the fourteenth century mural by the Sienese painter, Ambrogio Lorenzetti, "Good Government in the City." That mural is not the first representation of a city in Western art, but it is the first major work of art that shows the *life of a community* as the product of laws and traditions everyone recognizes.

What these examples demonstrate—psychologically and historically—is that before they have studied civics, sociology, or political science, most students have developed a concept of communal life plus some rudimentary ideas of the social conditions that make that life possible. That first image, that essentially benign idea of the community, lies behind everything they subsequently do as citizens acting in any public space or arena. If I am right, whatever is violent or tragic in the inner city, in the slum, in the "hood," represents a pathological distortion of the ideal existence depicted in our earliest images of the community. Those pathological distortions will not be soon or easily corrected, but without our earliest ideal images they cannot be corrected.

AGE GROUPING

Because art education is usually considered a matter of schooling, our discipline tends to be organized around the requirements of age and grade classification. This mode of classification leads almost most inevitably to an emphasis on psychological-developmental factors in constructing curricula, designing lessons, and shaping expectations of student performance.

Understandably, much professional lore in the discipline focuses on age norms for artistic production and critical-aesthetic response. As a result, special art materials and methods of instruction have been developed for the express purpose of demonstrating those norms at the right time and in the right grade. In this connection Arthur Efland[1] has described a "school art style," a mode of art-making that corresponds, more or less, to the exercises endlessly repeated by piano and violin students. Although real musical instruments are employed and real notes are played, they do not make real music.

Something important is missing in the "school art style," and yet lessons or exercises of graded difficulty seem to be essential for learning technique. Perhaps Beethoven's *Für Elise* represents the ideal answer to the problem. Easy enough for a young person to play, it can demonstrate a certain mastery nevertheless; it teaches technique but it is not a mere exercise: a piano piece like *Für Elise* exists at the level of real music.

So far as art education is concerned, the point of this illustration is that artistic quality need not, should not, be sacrificed for the sake of satisfying age or grade criteria. Our motto for art exercises might be: Simplicity of expression, yes; absence of meaning, no.

There is now a growing literature (under the heading "life-long learning") on art education for aged, retired, and senior citizens—a literature that has at least three sources. The main source is the belief that artistic activity represents a valuable use of leisure time. The progress of mechanical industrialism in the early twentieth century created a happy problem for social philosophers and educators—what to do with the abundance of leisure time at the disposal of those who formerly worked from sunrise to sundown, six days a week. Practicing an art seemed to be a healthy solution to their problem. In this view, making art represents one of the highest exercises of our distinctively human faculties.

Another source of the art-for-the-aged idea lies in the belief that artistic activity has therapeutic value, especially for that age group whose aches and pains are on the increase. This therapeutic source is less exalted than the leisure-time source because of its merely practical purpose. Nevertheless, it can be productive of higher values incidental to its pursuit of prag-

1 See Efland, Arthur. "The School Art Style: A Functional Analysis," *Studies in Art Education*, pp. 37–44.

matic ends. That is, older and retired people may use art to relax or "kill time," but in the course of learning to throw on the pottery wheel, or deciding on a subject to paint, they can make "higher" discoveries about work and technique, observation and representation, imagination and memory. These discoveries build on their life experience and, often, add to their pleasure in living.

A third source of the idea of art as lifelong learning arises from the belief that age confers wisdom which, translated into the language of art, adds to the sum total of society's values and delights. This view has strong connections to the philosophy according to which art is a source of truths that can be encountered in no other way. I share this view: art education as a discipline and art teachers as professionals should be committed to a philosophy that sees wisdom as much as exercise in making art and considering its meaning in our living and dying.

CLASS PHENOMENA

For educational purposes, social class translates into the economic status, occupational roles, and religious convictions of pupils' parents. That is, what pupils want to do in art is substantially determined by who their parents are, how much they earn, what they believe, and what they expect their children's schooling to accomplish. This leads art educators to take one of two paths. The first path entails the reinforcement of parental values and expectations. It is a path that teachers may follow automatically, unconsciously reflecting widely accepted notions about art and art instruction—notions about art's dedication to beauty, art as a language of true feeling, or art as a manifestation of special talents and gifts. It is a path that is often middle-class in its origins and assumptions about the meaning and purposes of culture.

The second path, which has deep roots in the artworld and is vigorously promoted in teacher education, maintains that art instruction represents an opportunity to reward culturally deprived, underprivileged, and disadvantaged pupils. Or, because art is a creative and therefore nonconformist activity, art education serves to honor the expression of unconventional feelings and antiestablishment ideas. If it is axiomatic that society's class structure is unjust or evil, then it follows that creative activity should oppose that structure explicitly or by inference.

Paradoxically, the second path in art education is often advocated by teachers drawn from society's middle or upper middle classes. As a rule, lower- and working-class people do not see art as a vehicle of social protest and change; that is something they are taught. Then why are middle-class cultural workers determined to upset the values and social arrangements that made them cultural workers? Because middle-class people are ambi-

tious and upward striving, which means seeing oneself as "down" and anxious to rise. That usually means denouncing the class from which one originates.

Class contradictions and anomalies in the lives of cultural workers in general, and art educators in particular, probably stimulate the "hidden curriculum" of art education. That curriculum is not hidden because teachers wish to deceive their pupils and supporting publics about the real purposes of their instruction. It is rather an artifact of a teacher's professional preparation, which promotes a worldview according to which art has always been an important part of society's adversary culture. This perception is supported, mainly, by the history of art since the French Revolution. However, it finds only intermittent support in earlier art, or in the art of non-European peoples. As art education draws increasingly on the resources of non-Western art, it will be necessary to realize that the adversary culture of the American middle classes is not a universal phenomenon. Which is to say, genuine professionalism requires art teachers to take culturally neutral positions.

RACE AND ETHNICITY

Racial and ethnic classifications in education have today assumed the importance formerly assigned to theological distinctions and faith affiliation. While art teaching practices based on religious holidays have not disappeared, their significance has diminished in comparison to projects designed to promote racial pride or ethnic self-esteem.

The prominence of race and ethnicity as major educational themes owes a great deal to the ideology of multiculturism. However, there are deeper reasons for this development. First, artistic creativity is widely considered a prime indicator of a people's inherent worth. Second, modern criticism and anthropology have exposed the ethnocentric biases implicit in older types of art instruction. Third, we consider the arts of preindustrial societies less commercial and hence more "authentic" than the arts of postindustrial societies. Finally, the art of so-called primitive peoples seems close to the imaginative life of children, hence it can serve as a model for their early art work. Implicit in this idea is the notion that art activity in the life of the individual recapitulates artistic development in the life of our species.

One can argue against each of the above mentioned ideas even though each contains a morsel of truth. Each of them, too, has served as a rationale for specific art teaching practices and whole art education curricula. As a counter-idea, we might consider the following proposition: The most potent influence on the artistic activity and aesthetic appreciation of older children and adolescents, regardless of racial or ethnic background, is the common culture mediated by film, television, video, and the print environment.

RELIGION

Notwithstanding the American doctrine of the separation of church and state, religion has long made itself felt in school art programs through the well-known holiday-art curriculum. In recent times, the three major faiths—Protestantism, Catholicism, and Judaism—have reached a kind of truce about how this curriculum should be implemented: Hanukkah has been added to the observance of Christmas and Easter. But now that pupils of Hindu, Islamic, Confucian, and Buddhist backgrounds increasingly populate the schools, that truce will have to be lifted. As for adherents of less well-known faiths, not to mention followers of no faith at all, their needs will probably require time to ripen before they are fully recognized in our schools.

The anthropological doctrine of cultural relativism together with the multiculturism movement in education represent our best known efforts to cope with the idea that no single faith should enjoy a monopoly in public education. To be sure, many religionists find multiculturism unacceptable since its approach to religious faith is *descriptive* in the ethnological sense rather than *prescriptive* in the moral sense. Clearly, the quarrel between religionists and secularists focuses on values: religionists believe any education worthy of the name should promote decent values, and they are convinced that decent values require religious sanction. Humanists, of course, would argue otherwise.

The problem of values (Whose values? When should they be taught? Who is qualified to teach them?) will not be resolved to everyone's satisfaction as long as we seek a *logical* resolution. However, we can point to a *pragmatic* resolution already achieved in the school celebration of Thanksgiving. Here is a case of a secular holiday with strong Biblical roots, originated by the Pilgrims, a deeply religious people, and universally observed by Americans. Nor is it a nonspiritual type of observance; the genius of public schooling has made it possible to invest the story of the Pilgrims, the Indians, and the Thanksgiving turkey with sufficient symbolism, ritual form, and moral purpose to satisfy the most ardent religionist. To a lesser degree, William Penn's treaty with the Indians serves a similar purpose. It has not been memorialized in a national holiday, but it expresses a genuine religio/political ideal.

So far as art teaching is concerned, this writer recalls an itinerant drawing master coming to his second grade more than sixty years ago. That master demonstrated the construction of a Thanksgiving turkey with broad strokes of colored chalk on the blackboard. We copied his turkey with wax crayons, producing a chromatically weaker but (to us) no less glorious bird. No doubt this was bad art education, although imitating and copying did not suppress our creative approach to turkey design. What matters is that personal artistry, a shared purpose, and the "high" meaning

of the harvest were fused in our collective imagination. The fact that the turkey is recalled, after so many years, suggests that the "lesson" was learned. It is still affectionately remembered.

Some have argued that the public school holiday-art curriculum trivializes religion and art. I think not; the art work in church-related schools is not substantially different or better from a technical standpoint. Even with its stereotyped symbols and decorative clichés, the holiday curriculum accomplishes a number of serious purposes. First, it introduces pupils to a genuine religious iconography, which is surely important to the faith community. Second, it teaches pupils that there are meaningful connections between visual forms and the world of convictions or values; that is surely important to the art community. Finally, it punctuates the school year with artistic and aesthetic occasions corresponding to the natural cycle of the seasons, the social cycle of work, and the human need for signs of forgiveness and regeneration. That is surely important to the secular community, even that part of it which has lost its taste for conventional symbols of transcendence.

SEX AND GENDER

Until recently, sex and gender were considered essentially biological, not social, domains. Perhaps that was because the division of society into only two groups—men and women—produces categories so large and diverse as to make generalizations about them almost meaningless. When it comes to art education, however, sex and gender are socially significant because most art teachers are women, and the men who teach art are often seen in a feminine light. Whether this is because school teaching has become an overwhelmingly female profession, or because artists, designers, and art teachers are considered unmanly, one cannot say.

There are at least three underlying reasons why art education is associated with the female sex: (1) teaching art, insofar as it is identified with the household crafts and the maternal role in nurturing children, is regarded as feminine; (2) art itself is regarded as a female activity because it clears no forests, ploughs no furrows, and fights no battles (although women today fight in wars); and (3) because hierarchies of value in curriculum theory assign a minor, that is, a subordinate or "feminine" role, to art in education.[2]

Notice that facts and empirical observation have little to do with these "reasons." For example, school teaching was considered feminine even when most teachers were males; and art making has long been re-

2 According to Kate Millett, femininity betokens powerlessness *regardless* [my italics] of gender. (See Millett, Kate. *Sexual Politics*.)

garded as feminine even though most of the artists known to history are men. These largely irrational notions about art, gender, and art teaching were understood, if not accepted, by teachers well before the advent of modern feminism. What the feminist movement has accomplished is to bring the myths and superstitions about the subject into the open.

If we acknowledge the folklore that surrounds art education, how should we confront it philosophically? Perhaps by not denying the feminine associations of art and art education (at least in America). We might ask instead why "real" men would want to detach themselves from life's aesthetic dimension. The psychological answer (almost too well known to repeat) is: insecure masculinity. The economic answer is: men work for wages, and art is what you don't get paid for. The aesthetic answer is: making art is fun but it bakes no bread. The sociological answer is: the Western division of labor has always assigned art (beauty, grace, and refinement) to women. The cultural answer is: life in the real world is strenuous, and women are better suited to tasks requiring gentleness and sensitivity. The philosophic answer is: art may be entertaining or lovely to look at, but it is not a source of reliable knowledge.

Of all these mistaken notions, the philosophic answer is the most dangerous since it is held by serious people and is often the recourse of persons who would find the other answers unacceptable. We shall deal with art as a legitimate type of knowledge in the final chapter of this book. Here it should be enough to say that the feminine associations of art have damaged its status as a subject of serious study. Naturally, this angers us: it points to the social and intellectual roots of the problem; it tells us why educators continue to see art as a frill; and it explains, without justifying, some of the shortcomings of our culture as a whole.

SOCIAL CHANGE

Is art education an agent of social change? Do art teachers by their instruction, contribute to the growth, transformation, or decay of social structures? And if so, are these changes deliberate or unintentional?

In answer to the first question, one can say that we are—like all teachers—agents of change insofar as we interrupt the natural processes of human growth and development in order to give them a shape. That "shape" is defined by our curriculum objectives, our professional ideals, and our personal culture. Even when formal art instruction produces resistance, it leads to changes beyond the classroom and outside the studio.

The answer to the second question is also "yes." Art teachers participate in social change by contributing to the transformation of our common visual culture. Through that visual culture students learn to see the world; through that visual culture the public decides what it admires or dis-

likes, what it wants and needs, and what it wishes to keep and chooses to discard.

The answer to our third question is that art teaching leads to social change intentionally and predictably as well as unintentionally and unpredictably. Our preoccupation with creativity, which is importantly related to human freedom, implies that institutions and environments, like images and objects, can always be transformed. Naturally, we hope the transformations are for the better; the art teaching enterprise is in its essential nature an expression of that hope.

The experience of visual change may be one of the most important contributions of art education to the idea of social change. For school pupils that experience is almost palpable in their artwork—in their manipulation of forms, styles of representation, employment of symbols, and attempts to control the environment through their depiction of a world. This is where the seed of an interesting idea is planted among students: the world with all its creatures and structures is subject to their will, imagination, and ingenuity. Later in life they (and we) learn that the world is not a very compliant subject. In reviewing our artwork we realize that the ideal worlds we picture tend to change frequently. Nevertheless, the plausibility of those early images—fantastic or not—establishes the idea of the *plasticity of all structures* built by human hands.

The phenomenon of world building in the art of children makes important connections to the principal determinants of social change: biological growth, technological transformation, and cultural authorization. The child's changing images of the world are a product of the same factors that lead people to change the conditions of their living despite the constraints of nature and tradition. This means that one's political consciousness is built on an artistic foundation. Stated differently, a democratic political consciousness cannot be built without an artistic foundation—personal experience with making and changing the forms of things.

When they are adults, students have citizenship conferred on them by right, and some of them exercise that right. At the deepest levels of consciousness they need to realize that social structures, and human behavior within those structures, can be changed—made better than they were. This notion of betterment has one of its roots, at least, in their earliest experience with the creation of artistic forms.

In the middle school and beyond, the study of art history and criticism builds on the idea of artistic and social change. Pupils now encounter concrete evidence of cultural differences. Interestingly, they ascribe these differences—consciously or otherwise—to *evolutionary change* from a prior natural state or "golden age." What is that ideal state? It is the perfect place depicted in their earliest world images. That "perfect place" is the mythic model and psychological starting point from which they measure every kind of progress or regress—in short, social change. For this rea-

son, the importance of art-historical study—the encounter with technical, thematic, and stylistic changes in human image-making—cannot be overestimated. It establishes the experiential model for understanding every kind of transformation—evolutionary or revolutionary—in every department of human affairs.

MULTICULTURISM

The subject of art history introduces the controversial topic of *multiculturism*. For art educators, that controversy is ironic since we have been multiculturists from the beginning. It is unnecessary, therefore, to persuade us that art has been created by every human group, in every known culture, in every period of history. This is something we have always known. Moreover, we have almost instinctively based our instruction on the fact that art is a universal human activity.

Accordingly, art educators view a multicultural curriculum as a good thing—if it is wisely constructed and used. However, multiculturism is often promoted on a specious ground, which I call "the demographic argument." This argument maintains that art curricula have always been expressions of dominant racial, ethnic, religious, and nationality groups. Hence, as the racial, ethnic, religious, and so on composition of a nation's population changes, its art curricula should change *pari passu*. That is, the mix of canonical works which are held up as exemplars of aesthetic quality should be changed to reflect the ethnic makeup of any particular student body. Implicit in this argument is the assumption that the English favor English art, the Italians favor Italian art, and the French favor French art, exclusively. A further implication is that the English think better of themselves to the extent that they see and admire Turner, Constable, Reynolds, and Gainsborough. In other words, the study of portraits by Sir Joshua Reynolds makes for a better British imperialist.[3]

The multiculturists' propositions about art curricula have some basis in fact, yet they constitute a flimsy foundation for a liberal education, that is, a curriculum fit for a free people. Liberally educated persons—whether of French, German, or Aztec descent—do not wish their knowledge and experience of art to be confined mainly to that sample of the world's art which was created by their ancestors. They want to be effective men and women, and for this purpose they are willing to study everything from Praxiteles to Hiroshige to Tamayo.

The demographic argument raises practical as well as theoretical questions. First, should curricula be constructed so that the art of every eth-

3 Alas for this argument, the greatest "English" painters of portraits were Holbein, a German, and Van Dyck, a Fleming.

nic group in a school or community is represented? Second, should that representation be proportional to the size of each ethnic group? Third, what happens when the ideal of representativeness conflicts with the ideal of quality or excellence? Fourth, how do we classify the work of "American" artists, whose racial, religious, and ethnic origins are obviously diverse? Fifth, how should we classify the art of women, who are also racially, religiously, and ethnically diverse? Sixth, is there any empirical evidence to support the notion that viewing Haitian, Cuban, Mexican, Puerto Rican, African, or Amerindian art enhances the self-esteem of students who descend from one or more of those cultures?

Clearly, the demographic argument creates more problems than it solves. Furthermore, it reflects badly on the professionalism of art educators; we should be able to think of better criteria—technical, stylistic, thematic, and so on—for making decisions about what to teach. Finally, for an absurd illustration of the weakness of the demographic argument, consider the case of a class or a school whose population is almost wholly of Mexican or African-American extraction. Should those students never, or rarely, see and study Asian and European art? Should their critical interpretations be considered valid only with respect to the art of their ancestors? It must be obvious that curricular decisions based on the ethnic, national, or religious origins of students can easily degenerate into racism, religious and ethnic triumphalism, political balkanization, and aesthetic parochialism—precisely what enlightened educators want to avoid.

Art enjoys a special advantage in education because—like music—its meanings are not restricted to those who speak the language of its makers. For this reason art educators have long taken a pluralistic approach to their discipline. Although it is not easy to read Homer in the original Greek, we can study Greek sculpture, Japanese prints, Italian mosaics, Chinese brush paintings, Navaho pots, and African masks without being able to understand the verbal languages of the people who created those art forms.

Our motive for doing Chinese brush exercises is not necessarily multicultural, although it can lead to an appreciation of the role of calligraphy in the cultures of China, Japan, India, and Persia. Usually, our motives are technical and aesthetic. Nor should those motives be disparaged: they grow out of admiration, they pay respect to the work of art and the effort that went into it, and they honor artists for their skill and imagination rather than their racial origin, class status, or sexual orientation. Regardless of motive, we are bound to prefer artistic reasons to political reasons for teaching a technique or studying an art form. Why? One reason is disciplinary self-respect: we teach and build on the foundations of what we know and can do as opposed to who we are and where we came from.

A more philosophical answer is related to the difference between political and aesthetic curriculum objectives. The discipline of politics is necessarily concerned with public power and how it is exercised, whereas

aesthetics is mainly interested in our private interactions with a class of objects we are free to ignore. Those private voluntary interactions may lead to public (including political) action, but here teachers move beyond their license to teach. That is, we may not compel students to like certain artworks or to act the way certain artworks imply they should act. Aesthetic education should enlarge our range of affections but it should not prescribe, that is, govern, our behavior.

In sum, we take cultural pluralism seriously as a legitimate goal of art instruction. That goal grows logically and naturally out of the historical, critical, and performative dimensions of our discipline. However, it does not require that we subscribe to a philosophy that denies what is obvious: all of us "own" art; it is the common heritage of our species. That should be sufficient to justify studying the art of any people, period, or place whenever we think it is technically, morally, or aesthetically appropriate.

THE "CLEAN CANVAS" SITUATION

As mentioned, every instance of art making has a world-building significance and as such it is a *starting afresh*—in Plato's term a "clean canvas" situation.[4] Karl Popper has pointed out that this idea can also be the starting point of totalitarian evil—the notion that society needs to be redesigned by an artist-tyrant who will "purify, purge, expel, banish, and kill" to achieve his aesthetic aims. Interestingly, Picasso has spoken of art making as "creative destruction." At this time, the former Yugoslavia is undergoing an orgy of "ethnic cleansing"—a pathological extension of the "clean-canvas" concept. The analogy between artistic composition and totalitarian violence is not without merit: to me it is technically and psychologically valid. Which means that the idealistic and perfectionist impulses which come into play during the processes of artistic execution are also related to the worst excesses of "social engineering." One hopes, of course, that art education represents a healthy, even prophylactic, defense against those excesses.

When Popper warned against an "aestheticist" approach to social reconstruction, he took art into consideration but not art teaching. Still, we cannot teach art without recommending the relocation of forms, the "neutralization" of forms, and the destruction of forms. Therefore, with respect to an overarching social philosophy we have a crucial responsibility: we need to alert students to the categorical differences between symbolic moves on canvas and actual behavior in the world.

From time to time one hears a peaceable artist—Robert Rauschen-

4 See Karl Popper's incisive discussion of "canvas-cleaning" in *The Open Society and Its Enemies, Vol. I: The Spell of Plato*, pp. 166–167.

berg, for example—speaking about "closing the gap" between art and life. Indeed, this book alludes to the beneficial effects of transferring artistic attitudes to real-life situations. Does that imply insensitivity to the violent and destructive potentials implicit in art teaching? No. We realize that cultural activities—making and criticizing art foremost among them—can have serious, even disastrous, consequences. But we may be too busy promoting art as "a good thing" to issue the warning that ought to be on the label of every strong medicine. Everyone does not know that art can be social dynamite. The images we make do not end their lives on school corridor walls: they find their way into human minds, into the language of civic discourse, and into the building blocks of culture. And that is a matter for serious reflection.

NEGLECTING THE SOCIAL

The graduates of our schools and colleges are astonishingly ignorant when it comes to architecture, and art education bears much of the blame. The neglect of this most social of the arts—which includes the art of building habitations for people and the design of communities, cities, and regions— is an educational disgrace. What are its causes?

First, as Herbert Read pointed out years ago, art teachers prefer to center their instruction on drawing, painting, and modeling, with some printmaking and craft work thrown in. This reflects their studio training and experience. Apart from their college survey courses in art history, future teachers are rarely exposed to architecture as the "mother of the arts," as the art that most directly affects society, or as the expression of a civilization's ideas about the way people should live, work, and "be with" each other.

Second, the study of architecture as a form of cultural expression does not usually result in tangible classroom products, and art teachers are still biased in favor of products that can be made by students and displayed in class. Also, many teachers are reluctant to teach a class by using slides or reproductions; they prefer the atelier or one-on-one mode of instruction, which usually involves personal demonstration, correction, and advice. Indeed, researchers have found that some art teachers address an entire class only when giving directions, but rarely when dealing with matters of large aesthetic substance.[5]

Third, we think of architecture as an art so deeply involved in technology that it properly belongs in the curriculum of industrial arts. Again, art education suffers from the illogical separation of technics and aesthet-

5 Aristotle says, "For there is nothing grand or noble . . . in issuing commands about necessary things." (See Aristotle. *Politics*, Book VI, Chapter 2.)

ics. As for the curricular space assigned to the crafts, it reflects our notion that simple technologies support aesthetic values while complex technologies really belong to engineering.

Fourth, the ideology of art education is skewed toward individual and personal, rather than collective and social, modes of production and appreciation. It is no accident that psychologists have had more influence than sociologists in the determination of what, how, and why we teach. No doubt this is because art people tend to be passionate individualists. Of course, architects are individuals, too, but they belong to firms, they often work in teams, and their art is a product of the skill and effort of hundreds, even thousands, of technicians and artisans. Architects typically work through others, but our professional ideology finds it difficult to cope with art forms that are truly collective creations.

If there is an overriding reason for the neglect of architecture in education, it is our predisposition toward romanticist philosophies of art. The research, the literature, and the teaching methods of art education emphasize the primacy of the individual in art making, the supreme reality of subjective feelings, the high importance of personal expression, and the respect that should be paid to artists marching to their own drummer *despite the public's resistance.* These romantic/heroic values are often considered the unique contribution of art to education, so we are loath to do anything that might detract from their centrality in our teaching. Still, it would be wise to remember that art and education are subject to cyclical change: an excessive romanticism can induce an ill-considered classicism; overindulgence in self-expression is a luxury our discipline cannot afford; a cultural reaction could strangle the creative values we believe we are promoting.

TEACHERS AS CULTURAL WORKERS

Do art teachers have any institutional allegiance higher than the school? Is art education animated by an idea of the social larger than race, clan, family, nation, class, or people? Our ultimate affiliation is with our species—*homo sapiens*—although here the idea of socialness is perhaps too zoological. As teachers and artists we know we belong to a species that is more than the product of a long biological evolution. Because we are culture making, culture-using animals, we think we have some limited power to shape the career of our species on this planet.

If this statement of our role and situation is right, art educators are specialized cultural workers whose mission it is to advance the human development of our species by using as tools the images that *homo sapiens* is uniquely equipped to make and understand. We pick up, so to speak, where evolution leaves off.

Certain conclusions can be drawn from the fact that we are cultural

workers with a responsibility for transmitting a decent idea of the social to successive generations of students. The first glimmerings of that idea in art appear when children discover that their image making is more than a sign of their aliveness or an expression of their power over the phenomenal world. Teaching fosters that discovery; the social character of art instruction teaches children that art is a type of making *for,* showing *to,* and communicating *with,* someone else.

Every pupil needs to learn that satisfaction in one's work requires that it be accepted, understood, and possibly enjoyed, by at least one other person. This is the art teacher's special contribution to the development of a civilized sense of the social, the notion that personally initiated activity requires external validation to confirm its significance and worth.

We also teach with the tacit understanding that while art is usually an individual creation, it is also a socially determined phenomenon. The art teacher, in her role as critic and mentor, acts as a surrogate for the larger community of viewers and consumers. Ideally, teachers perform this task for pupils until they have internalized its meaning, that is, until they understand the *significance of the social* in their personal seeing, making, and valuing.

Finally, because we are cultural workers, we look forward to a society in which art is a special case of a general condition in which human beings live in relations of continuous meaning with each other. Without maintaining that society should itself be an art form, we believe all social relations should strive toward the conditions of meaning that art at its best exhibits. That, of course, requires us to be familiar with "art at its best." In short, we have to be aesthetically literate.

CONCLUSION

Following are some statements and observations about the principal terms and topics discussed in this chapter.

To create an image for others to see is a *social act.* For children, the serious business of *socialization* often begins with drawing, painting, and modeling in class, where teachers and others respond to what children have made. Through the *institutional* sponsorship of image making, pupils receive basic training in *mutuality;* they discover their real and *symbolic interdependence.* Because school art has a public character, the processes of making and valuing are accompanied by a growing sense of *community.* An art teacher is a *surrogate* for a community which knows and cares about what its members make and say through their work.

Socialization through art also develops the individual's sense of belonging to the general body of humanity. *Acculturation* through art is a process of acquiring the aesthetic habits or traits of a particular social

group. *Art history* is the discipline through which students learn about the visual-symbolic legacy of their own and other social groups; it constitutes the *anthropological* dimension of art education. *Multicultural* art education properly belongs to the process of socialization: students learn about the general body of humanity by studying the varied arts created by our species. Multiculturism is improperly used if it seeks acculturative ends, which can degenerate into *ethnic propaganda* and *social divisiveness*. With respect to all human cultures our motto should be: We study the particular in order to understand the universal.

The concept of *class* bears on art education in that preferences for certain styles, themes, and genres are associated with social groups defined by their education, occupation, wealth, and ethnicity. *Class consciousness* is the awareness of *class interests* based on a group's economic role and its perceptions of the advantages conferred or denied by various kinds of cultural production. Art teachers, given their largely middle-class origins, tend to see themselves as evangelists for middle-class taste, which they regard as evidence of fitness for higher *social status*. They confuse their commitment to education as *systematic change* with an obligation to *impose* aesthetic values; it would be better to see art education as the *clarification* of aesthetic issues and values. Students know when they are being indoctrinated rather than informed. The irony here is that art teachers may not realize how much of their teaching consists of stylistic enthusiasms based on middle-class faddism—a type of upwardly mobile striving that represents the bourgeois version of *class struggle*.

Art and *human sexuality* are closely associated because visual images often describe persons according to gender. Notice that "gender" has changed from a grammatical term to a word designating *culturally assigned* sex roles. *Sex role* refers to a range of behaviors extending well beyond the biological and reproductive to the social and psychological functioning of human beings. Thus, art education is often given a *feminine* role (presumably it is gentle, subordinate, and nurturing) while engineering is considered *masculine* (presumably it is aggressive, dominant, and masterful). The tensions between these poles of personality and behavior are commonly expressed in artworks ranging from the *loving* to the *romantic* to the *affectionate* to the mildly *erotic* to the *pornographic* to the violently *obscene*. These terms comprise what might be called the *spectrum of eros*. Teaching art often consists of delicately maneuvering along that spectrum. When our maneuvers are done, we hope we leave a residuum of love.

Because art changes continuously, art education necessarily participates in *social change;* but social change is not identical with *progress*. Progress in art is a questionable concept: there is no internal evolutionary principle that makes today's art better than yesterday's art. On the other hand, individuals—students and teachers—can progress in their knowledge and understanding of the world through art. Ultimately, art education

promotes beneficial or progressive social change in the light of its *discipli-nary commitment* to forms whose meaning is conducive to *human growth*. Our disciplinary commitments are protected by *lehrer freiheit,* or academic freedom, which implies our right to define the profession's disciplinary practices and ideals. If our goals are externally defined, they become matters of political dictation, and art education becomes an appendage of something else.

Communities are collections of physical structures as well as *networks* of social relations. To the extent that their structures are wisely organized, communities have *architectural form.* But without *organic design,* without a sense of *aesthetic* limits, communities turn into cancerous growths. Which is to say, the spatial form of every community reflects the *social-aesthetic competence* of its inhabitants. Education—especially art education—is responsible for developing that competence. Our goal is a core, at least, of *architecturally literate* citizens, without whom healthy social relations and a rich civic life are denied to everyone.

REFERENCES

ARISTOTLE. *Politics,* Book VI, Chapter 2. Benjamin Jowett (trans.). New York: The Modern Library, 1943.

BARZUN, JACQUES. "The Arts, Snobs, and the Democrat" (1939). In Morris Philipson, ed. *Aesthetics Today.* New York: Meridan Books, 1961.

BLAKE, PETER. *God's Own Junkyard: The Planned Deterioration of America's Landscape.* New York: Holt, Rinehart and Winston, 1964.

BURNHAM, SOPHY. *The Art Crowd.* New York: McKay, 1972.

COMFORT, ALEX. *Art and Social Responsibility.* London: Falcon Press, 1946.

DEWEY, JOHN. *Reconstruction in Philosophy.* New York: Mentor Books, 1950.

EDGERTON, ROBERT B. *Sick Societies: Challenging the Myth of Primitive Harmony.* New York: Free Press, 1993.

EFLAND, ARTHUR. "The School Art Style: A Functional Analysis," *Studies in Art Education,* 17 (2), 1976.

FELDMAN, EDMUND B. "Varieties of Art Curriculum," *Journal of Art and Design Education,* vol. 1, no. 1, 1982.

FELDMAN, EDMUND B. *The Artist: A Social History,* 2nd ed. Englewood Cliffs, NJ: Prentice Hall, 1994.

GANS, HERBERT J. *Popular Culture and High Culture.* New York: Basic Books, 1974.

GIEDION, SIEGFRIED. *Space, Time and Architecture.* Cambridge, MA: Harvard University Press, 1954.

GOODMAN, PAUL and PERCIVAL. *Communitas: Means of Livelihood and Ways of Life.* New York: Vintage Books, 1960.

GOTSHALK, D. W. *Art and the Social Order.* New York: Dover Publications, 1962.

HALPRIN, LAWRENCE. *Cities.* Cambridge, MA: MIT Press, 1972.

HAUSER, ARNOLD. *The Sociology of Art.* Chicago: University of Chicago Press, 1982.

HOEKEMA, DAVID A. "Artists, Humanists, and Society," *Art Journal,* Fall, 1991.

HOFSTADTER, RICHARD. "The School and the Teacher," *Anti-intellectualism in American Life.* New York: Knopf, 1963.

JACOBS, JANE. *The Death and Life of Great American Cities.* New York: Random House, 1961.

JENCKS, CHARLES A. *The Language of Post-Modern Architecture.* New York: Rizzoli, 1977.

KAVOLIS, VYTAUTAS. *Artistic Expression: A Sociological Analysis.* Ithaca, NY: Cornell University Press, 1968.

LEVI-STRAUSS, CLAUDE. *Structural Anthropology.* Monique Layton (trans.). New York: Basic Books, 1976.

LYNCH, KEVIN. *The Image of the City.* Cambridge, MA: MIT Press, 1960.

MCIVER, ROBERT. *Social Causation.* Boston: Ginn & Company, 1942.

MEAD, GEORGE H. *Mind, Self and Society.* Chicago: University of Chicago Press, 1934.

MILLETT, KATE. *Sexual Politics.* Garden City, NY: Doubleday, 1990.

MURPHY J., and R. GROSS. *The Arts and the Poor.* Washington, DC: Government Printing Office, 1967.

NOCHLIN, LINDA. "Why Are There No Great Women Artists?" *Art News,* January, 1971.

ORTEGA Y GASSETT, JOSÉ. *The Dehumanization of Art.* Princeton, NJ: Princeton University Press, 1951.

POPPER, KARL. *The Open Society and Its Enemies,* 2 vols. New York: Harper & Row, 1962.

RASMUSSEN, STEEN EILER. *Experiencing Architecture.* Cambridge, MA: MIT Press, 1959.

READ, HERBERT. *Art and Society.* New York: Schocken Books, 1966.

REISMAN, DAVID. *The Lonely Crowd.* New Haven, CT: Yale University Press, 1950.

ROSENBERG, BERNARD, and NORRIS FLIEGEL. *The Vanguard Artist: Portrait and Self-Portrait.* Chicago: Quadrangle Books, 1965.

RUBIN, WILLIAM, ed. *"Primitivism" in 20th Century Art: Affinity of the Tribal and the Modern,* 2 vols. New York: Museum of Modern Art, 1984.

RUSKIN, JOHN. "Architecture," in Kenneth Clark, ed. *Ruskin Today.* Harmondsworth, Middlesex: Penquin Books, 1964.

SCHAPIRO, MEYER. *Theory and Philosophy of Art: Style, Artist and Society.* New York: George Braziller, 1994.

Schücking, Levin L., "Shifting of the Sociological Position of the Artist," *The Sociology of Literary Taste.* London: Routledge & Kegan Paul, 1944.

TORGOVNICK, MARIANNA. *Gone Primitive.* Chicago: University of Chicago Press, 1990.

VON BLUM, PAUL. *The Art of Social Conscience.* New York: Universe Books, 1976.

WOLFE, TOM. *From Bauhaus to Our House.* New York: Farrar, Straus and Giroux, 1981.

ZIMMERMAN, CARLE C. *Family and Civilization.* New York: Harper & Brothers, 1947.

THE ECONOMIC DIMENSION

INTRODUCTION

John Dewey taught us that art is a type of experience, but he would not deny that it is also a commodity. The fact is, art is an economic good which requires time and money to produce; it is a type of work that can be exchanged for other goods, work, or money. Art also has a labor-and-materials value that enters into its cost. That cost, curiously, does not necessarily affect its price. Nor does its labor-and-materials value necessarily affect its aesthetic value. These anomalies can be explained—in part, at least—by the concept of *quality*. Quality might be defined as what people are willing to pay for over and above the cost of tools, materials, and labor.

If quality is a ponderable factor in the economics of art, then art education is implicated because (1) we acquire notions of quality from our own art-making experience; (2) we learn about quality from studying works created by artists reputed to be good; and (3) most of us buy, use, and preserve objects we believe are good in some sense beyond their physical utility. From an aesthetic standpoint, it can be argued that quality represents a type of "added value" that *ought* to affect the economics of production and price.

Apart from quality considerations, art education has economic significance because of its deep involvement in the teaching of skills. Although those skills are not directly employed in modern industrial production, they are a vital part of a worker's makeup. Insofar as skills play a role in the formation of a person's character, they influence that person's economic behavior regardless of his or her occupation or social background.

Finally, art education has an indirect but nevertheless potent effect on the economics of consumption. Consider only the controversies surrounding taste and fashion, style and styling, expression and decoration, beauty and efficiency, real and forced obsolescence. These opposed concepts emerge in serious art instruction, especially in secondary schooling; they frame artistic, technological, and aesthetic issues for students, who develop "attitudes" about them. These attitudes make themselves felt in market research, design innovation, financial investment, industrial planning, marketing strategies and, ultimately, commercial success.

We tend to overlook the connection between art and economics because of differences in their respective languages, or jargon. Even so, we have at least two words in common: goods and values. This reminds us of the fundamentally artistic, that is, technical, character of goods, and the aesthetic character of the *values* we believe inhere in those goods. Our economic system is so complex, and its language is so abstract, that we may forget its roots in the production/consumption process discussed in this chapter. As for art education, which can also get lost in jargon, it would be interesting to think of creative activity as a type of entrepreneurship. In that case, our students might be considered risk-takers; they have "capital" which we try to help them use wisely.

MEANS OF PRODUCTION

Among the various types of schooling, art education is probably the most fastidious in its attention to tools, materials, and processes of making. It does not matter greatly to an English teacher if a student's essay is typed, written with a ball-point pen, or printed out on a word-processor. For an art teacher, however, there are worlds of difference between drawing with a pencil, pen-and-ink, crayon, chalk, or a Chinese brush.

We are the same as skilled workers who are over-particular about their tools and materials. Our valuation of the *means of production* is tied very closely to our valuation of the *outcomes* of production. Why? Because art education represents the institutionalization of certain ideas about the way things should be made. What are those ideas?

First is our insistence that any type of art making be consistent with the *full human stature* of the maker. Whether the artist is a child or an ado-

lescent, an amateur or a professional, he or she must not be reduced to an anonymous factor in the process of production.

The second idea, a corollary of the first, is that tools and materials should be selected according to their capacity to maximize a person's powers of discovery, organization, and expression. The human impact of a technology takes precedence over its economic convenience or efficiency.

Third, we believe tools and materials should be respected without becoming a fetish. That is, the process of art making should not be permitted to outrun or transcend the significance of the final product or the function of the product in humane consumption.

Fourth is our emphasis on the *authenticity* of a product in the life of its maker. This principle should be observed by every artist, but in art education it has special urgency because no child should be required to make something that does not grow honestly out of his or her experience.

Fifth, we believe the pleasure one takes in a work of art should be contingent on the humaneness of the technologies used to make it, the decency of the conditions in which it is made, and the fairness of the reward it brings to its maker.

Behind these notions about the rightness or wrongness of process/ product relationships, there is the conviction that moral considerations should outweigh economic considerations when it comes to judging any "means of production." Perhaps there is a socialist residue in this point of view; it derives from the Marxist analysis of primitive production as good, and civilized or capitalist production as bad. Wittingly or not, many art educators subscribe to this analysis because it conforms to their experience with making art in the school or studio versus working at a job in a factory.

Happily, industrial work has been greatly humanized since the days when Marx and Engels wrote about Manchester's factories, and Dickens wrote about working conditions in England's "satanic mills." To some extent, the ideology of modern art education is a reaction to their impassioned prose. That ideology also expresses our resistance to depersonalization in modern processes of making. In effect, it is a plea for balance among all the factors of economic and artistic production.

AESTHETICS OF PRODUCTION

For art educators, the economics of production may seem less important than the aesthetics of production. We know that artistic creation "looks forward" to economic consumption, but we are not excited about the fact. When we make something we are not especially concerned about what it costs in time or effort, who will pay for it, or who will use it. Instead, we concentrate on how an image or object should be formed, what it should

look like, and (when it is finished) whether it lives up to our fondest expectations.

Asking questions about function, appearance and meaning, guessing at their answers, exercising our forming skills, hoping for agreeable outcomes, and judging actual results: these operations lie at the heart of teaching, making, and evaluating art. In the aggregate they constitute an economic process—production—which has an economic effect—consumption—the process of using or enjoying the product of someone's labor and imagination.

What the art-making process demonstrates conclusively is that there can be no consumption without production, and there can be no serious production without the anticipation of consumption. No matter how solitary the creative act seems, it is always a step in a social process that has a strong economic character: someone may see, like, acquire, and *use up*, what the art maker has created.

Using-up does not mean annihilate: just as art making entails the "destruction" of materials in order to make something new, the process of consumption entails the quasi-destruction of an artistic good. In aesthetic perception, however, consumption entails the virtual destruction of the object as originally constituted and intended. The act of examining a work of art involves its analysis or "deconstruction" followed by its reconstitution in the act of understanding and interpretation. This is a subtle point, but it needs to be mentioned because it calls attention to (1) the "creative destruction" that takes place in making, using, and criticizing works of art; and (2) it urges art teachers to appreciate the fact that creative activity contemplates social use, critical response, and aesthetic consumption.

The fulfillment of artistic production in aesthetic consumption has important significance for art education. It means that creative activity cannot be viewed solely in terms of self-expression. So far as teaching and learning are concerned, art belongs to a *process of communication*. In educational settings, at least, art is made to be seen and understood; it is created to elicit a human response. That response may come from teachers, from other students, or from the community at large. Without that response the art experience is incomplete. With it, a powerful model of social and economic accountability is created.

AESTHETICS OF CONSUMPTION

We talk about consumption separately while fully aware of its organic connection to production. Making art and looking at art are two sides of the same coin. When thinking about consuming any good thing, we have to think about the how and why of its production.

Among educators and lay people, aesthetic consumption is usually equated with art appreciation. Unfortunately, art appreciation is sometimes regarded as a weak form of art history. It is not. When properly taught, art appreciation is an intellectually and emotionally demanding discipline which entails the integration of history of art, philosophy of art, psychology of art, and aesthetics. Interestingly, the word which lies at the heart of that integration—appreciation—is an economic term.

Our term "appreciation" is rooted in the Latin word for price or *prex*. The prospect of economic gain is not wholly absent from our aesthetic adventures, although we might wish it were otherwise. This is because people who live and work in market economies almost automatically estimate the costs, and hence the fairness, of the prices of whatever they use or enjoy. To be sure, this interest in prices is considered vulgar by some persons. Indeed, Oscar Wilde accused Americans of knowing the price of everything and the value of nothing. But perhaps this is because we care more deeply than Oscar about the labor value implicit in any form of production.

The questions students or "uneducated" persons ask in the presence of an artwork—What did the materials cost? How long did it take to make it? How much is the artist's skill worth?—translate into quite sensible inquiries—Is the price of this object a fair reflection of the labor that went into it? How does the market "cost out" or determine the value of an artist's imaginative effort? And how do I decide whether this work deserves the expenditure of my time?

These questions should not be despised, and they invariably come up in the course of teaching art. Furthermore, and much to our chagrin, students believe an economic model of production influences the grades they earn. That is, they think teachers make quasi-economic calculations when assigning value to their artwork. At some level of awareness, students know that a grade is more than a psychological assessment or a mode of comparative ranking. They believe a grade results from a complex of cost estimates: the imaginative costs of invention, the technical costs of fabrication, the aesthetic costs of close examination, and the critical costs of judging and justifying.

If this analysis is correct, students come to realize that the evaluation of their performance has a large economic component: the cost of examining, criticizing, and appreciating their work amounts to setting a price on their work. In a real sense, therefore, art teachers are art consumers; they complete the process of production by "using" and assigning a use-value to the student's imaginative and technical effort.

An economic model of instruction is clearly more pertinent to *art* teaching than to other modes of instruction because tangible objects are so obviously central in every artistic enterprise. It is obvious, too, that an art teacher's aesthetic "consumption" is different from a science teacher's

marking of exams and grading of examinations—not more difficult, but different in character. Still, an economic model goes only so far; there is much that it does not explain. Nevertheless, economic factors play a real role in art instruction and we would be unwise to ignore their existence.

THE CASE FOR CRAFT

Given our model of art as production-consumption, crafts education may represent our best approach to economic reality and social responsibility. Consider the potter, the metalsmith, the woodworker, and the textile designer: their traditions are rooted in design for utility, in production for use, in art that works for people. A craft object, by definition, includes in its conception and plan an actual or potential customer. While some may regard the crafts as obsolete modes of production, we cannot ignore the economic implications from which many of their educative values flow. What are those values and implications?

First is the most obvious: the development of *hand skills*. This value hardly needs describing since it is so clearly connected to our human identity; after all, we have been called tool-using animals. Consider, too, that notwithstanding the rise of computers, teachers of art still work with their hands. In addition to the satisfaction of using our hands, building muscle memory, and increasing hand-eye coordination, there is the enhanced sense of personal worth that comes from *adding value* to materials by the use of one's personal resources—bodily equipment, focused energy, and the stuff of one's imagination.

Second is the development of the idea of *form/function* relationships. This by no means simple concept is difficult to acquire through other kinds of education, yet it begins in the craft activity of elementary school pupils. Interestingly, this activity is very efficient from a cognitive standpoint. Making a clay pot by the coil method fosters high-order conceptual development even if the pot is not especially impressive as art. Furthermore, craft people know that creating forms with one's hands has a cost which is reflected in the monotony of oft-repeated operations, in the distinctive weariness of the craftsman, and in the awareness of *meanings gained or lost* through irretrievable forming decisions.

A third value lies in the learning generated through *overcoming the recalcitrance of materials*. Apart from the personal victory this activity represents, there is also the discovery that materials have potentials for use and expression that can be "forced out of them," so to speak. This is more than a psychological discovery; it is a demonstration of the almost infinite possibilities of meaning that can be created through skilled work. It is also convincing evidence of the fact that works of art have a "real-world" existence.

A fourth value is *mastery of process*. Craftsmanship encourages confidence in tools and operations if they are managed in the right way. We

need not disparage the notion of a "right way" to manage tools and mate-rials. Good management of processes is not necessarily anticreative; it be-longs to the business of acquiring technique. We are speaking here of craftsmanship, which is partly learned by acknowledging that some meth-ods are better than others, that bad management of tools and processes gets us into trouble, and that experienced persons—teachers—know how to get us out of trouble.

Perhaps the highest reward of an education in craft might be called its *moral-economic dividend.* Here we learn that there is an honest way to use tools, materials, and processes; that it is possible to create false appear-ances; that skilled persons can add spurious "value" to practical objects; that one can deceive the public about the usefulness, durability, or aesthetic worth of anything one makes. From an education in craft we learn that these forms of deception are economic and ecological sins. They are morally wrong: if we deceive others by craft, then we dishonor ourselves.

THE FLOW OF GOODS

Apart from the production and consumption of goods, economics is con-cerned with the movement of goods through society. That movement or flow—described in the dreary language of economists as supply, demand, market concentration, elasticity of demand, and so on—is perhaps the most puissant force for progress that we possess. Indeed, trade and com-merce may have done more than law and philosophy to advance civiliza-tion. Where or how does art education fit into this civilizing process?

Only one economic principle is needed to establish the connection: the law of *diminishing desirability.* This law states that the first hamburger tastes better than the second, the second better than the third, and the third better than the fourth(!) hamburger. It also explains the importance of orig-inality in art, the decline of an art style after it has been very popular, the cycles of change in taste, and our tendency to add salt to food as we grow older. More to the point of this discussion, the law of diminishing desir-ability reminds us again of the large role played by aesthetics in the eco-nomics of production-consumption. The movement of goods through the economy depends on the ability of sellers to arouse and sustain the *demand* for those goods among buyers. That demand depends on (1) the need for certain goods, (2) the price of those goods, and (3) the desirability of the goods *in the eyes of those involved in their production and use.*

As soon as we introduce the concepts of "need" and "desirability" we open the door to art and design concepts such as utility, durability, conve-nience, appeal, emotional resonance, symbolic association, and suitability of form to function. Clearly, the flow of goods is promoted or impeded by aesthetic criteria which are learned more than they are inherited. In a good

society, art instruction would implant the images, standards, and models of production-consumption that ought to govern notions of desirability in all objects of everyday use. Our students would employ those models and act on those notions long after the completion of their formal schooling.

But perhaps this is the special pleading of an art educator. Is there any evidence of a connection between economic activity and the aesthetic education of consumers? Yes, and it lies all around us. Virtually every object we see, or want to buy, or refuse to own, is calculated to appeal to the public on the several grounds of desirability mentioned. Manufacturers expend huge sums in order (1) to improve the appearance and, by implication, the utility and worth of their products; and (2) to persuade consumers that a certain product is better because it looks better or newer, or both. The first type of expenditure is called *appearance design;* the second type is called *advertising,* or "demand creation."

Whether we like it or not, advertising (or demand creation) is one of the high arts of our age. It promotes the flow of goods, and it generates pleasure in the processes of consumption. Unfortunately, it often promises more than it delivers. It also shows that visual appeal can be built into a product authentically or inauthentically. We may conclude that in free societies, at least, industry and commerce will not prosper if they are indifferent to the aesthetic perceptions of the public.

Consider the fact that after the Berlin Wall fell, and as West Germany absorbed East Germany, no one would buy the less-than-beautiful East German car, the Trabant, at any price. Then, as Western cars became available, people made large personal sacrifices to buy them; the factories that manufactured the Trabi had to be dismantled. We may fairly say that aesthetics came into play when the market was liberated.

Does this mean that art education is, or should be, predisposed toward free market economics? Not necessarily. Socialist states committed to central planning and command economics have aesthetic convictions—not unlike those advocated by the Bauhaus—which they promote through education and indoctrination. What we can assert with confidence is that a free market in goods is closely related to a free market in aesthetics. And a free market in aesthetics requires a free market in ideas. So if we believe there is a connection between art and economics, and if we teach design principles *in social and economic context,* then those principles should be freely chosen.

OUR MIXED ECONOMY

If the distinguishing features of capitalism are competition, free markets, production for profit, and private ownership of the means of production, then art education in the schools operates under socialist principles. Notwithstanding the collapse of the world's major socialist economies toward

the end of the Cold War, many artists, intellectuals, and educators continue to see capitalism in a negative light. Some variant of socialism—a *perfected* variant, to be sure—seems better suited than capitalism to our personal, professional, and creative needs. In this respect we seem to share the views of self-supporting artists who have not as yet become rich and famous.

The generous support of the arts by merchants and capitalists—from the Renaissance Medici to the "robber barons" of the nineteenth and early twentieth centuries—does not seem to matter since we ascribe their generosity to motives of conspicuous waste, conspicuous display,[1] and feelings of guilt. As a result, the arts community finds itself in a conflict: it loves and avidly pursues the patronage of wealthy persons and institutions (museums, foundations, and major corporations) while it despises the individuals who dispense that patronage. This conflict permeates the ideology of the art community, including that of art educators who are only peripherally affected by the private patronage system.

In our overall economy, the system that supports gallery artists owes more to capitalist success than to socialist benevolence. Nevertheless, art educators tend to share the outlook of artists caught up in a love/hate relationship with their rich patrons. This is especially ironic in view of the fact that art teachers are not usually involved in the gallery "scene"; we are the beneficiaries of a different arrangement—the largest and most expensive *public* patronage system in the history of art (see *Public Support,* chapter 3). Still, we identify with the gallery-chasing, collector-courting, grant-seeking artist whose livelihood depends on the ephemeral tastes of dealers, museum curators, and art bureaucrats. Why? What accounts for this contradiction?

The simplest answer is the human one—we would like to have our cake and eat it. We prefer to think Left and live Right. A more serious answer lies in the generally romantic ideology of art educators: we have genuine feelings of nostalgia for the aristocratic patronage system that prevailed before the democratic revolutions of the eighteenth century. The largesse of a king, prince, or high churchman, dispensed from a magnificent palace or cathedral, seems vastly more glamorous than the cold cash paid by a dealer operating from what amounts to a store-front boutique. Although we receive wages from a school district, we would rather take money from a royal purse.

Even without fantasies of aristocratic support, it seems to us that a humane system of education has to be conducted along democratic socialist lines: the conditions of capitalist competition are too severe for children who are still learning how to live cooperatively in groups; the noncompetitive ideals of socialism seem especially appropriate for the early stages of

1 We are indebted, of course, to Thorstein Veblen for these terms as explanations of the "aesthetic" behavior of the very rich under capitalism. (See Veblen, Thorstein. *Theory of the Leisure Class.*)

learning and growth. At the same time we realize that young people are being prepared for life in an economy where all forms of production—including "fine art" production—are risky ventures subject to the indifference of buyers, stylistic obsolescence, and "business" failure.

Perhaps our ideology is socialist in professional self-defense. Schooling is largely a state enterprise; the salaries of art teachers are paid by the state; tools, materials, and facilities are supplied by the state; our "managers" or administrators are officials of the state; and our students' production is exempt from the conditions of market competition.[2] Also, the typical art education "product" is not created to be sold, it is not motivated by the expectation of profit, and the cost of its making has little to do with its artistic, educational, or aesthetic value.

Because of these factors there is a conflict between the ideals of cooperation that we believe should prevail in childhood education and the rigorous demands of market competition that are likely to prevail when our pupils grow up. With respect to this conflict, art education is ambivalent. As mentioned, we admire and would like to enjoy the privileges that an aristocracy—royal or mercantile—bestows on artists as they climb the greasy pole of success. At the same time, we rather enjoy the patronage dispensed by a system of almost pure socialist benevolence.

The conflict between our capitalist dreams and our socialist ideology is curiously productive: it generates a tension that can be personally and professionally creative. From one pole of that tension we get the socialist analysis of production for human use rather than maximization of profit. From the other pole we get the capitalist search for new needs, new products, and larger market share, which is the principal engine of change in our economy. The institutional tensions between cooperation and competition are not likely to disappear; the long-term prospects for our discipline will depend on our ability to tolerate their stresses and reconcile their differences. If we are clever, if we recognize that our aesthetic economy is a mixed economy, then we may learn to convert the tensions between the extremes into a source of strength.

DESIGN EDUCATION

As early as 1934, Herbert Read called attention to the importance of "the education of the consumer in aesthetic appreciation" and "the education of the producer in aesthetic design."[3] This was necessary, in his opinion, be-

2 For John Kenneth Galbraith there is a close connection between state patronage and artistic excellence: "Artists have always *functioned best* [my italics] under the most lavish handouts of the state." Statement given at Airlie House Seminar of the Associated Councils of the Arts, June 22, 1967.

3 See Herbert Read, "Art Education in the Industrial Age," *Art and Industry,* p. 163.

cause of the bad design of manufactured products promoted or tolerated by industrialists, sales managers, retailers, and the comfortable "middle-middle-class(es)." Read believed the poor design situation in England could be changed by stimulating a "higher level of public taste"—a challenge to education. If art education did the job, industrialists would be unable to excuse themselves by claiming (like today's television executives) that they produce only "what the public wants."

Happily, product design has made great progress since the days when Read wrote and lectured. Can we say that art education played a role in effecting that progress? Yes, if we count the educational efforts of museums and galleries of modern art, college teachers of industrial design, and the publicists hired by enlightened manufacturers. But if we consider the curricula and teaching of art educators in the schools, the effort has consisted mainly of "lip service." Why?

The answer is partly philosophical. We have been reluctant to admit that industrial products have aesthetic relevance and value. Or, if we concede they have aesthetic value, we do not know what to do about it. Art teachers typically make a model or an image of something they want to study. This restricts the range of objects one can learn about, creating special difficulties when the "object" we want to study is a cathedral, an airport terminal, or an entire city. Slides and reproductions help immensely, but many teachers will not use them. Why? Because they believe, as Read charged, that teaching art is essentially a matter of teaching drawing, painting, and modeling.

Behind this narrow conception of the discipline lies our training as artists and—something that goes with our training—a rather romantic notion of what art is. Our romantic, anti-industrial conception of art has roots in the outdated art histories we had to study in college and—surprisingly—in the psychologies of art employed by many theorists of creativity. For them, the artist-type is almost invariably an easel painter whose personality is patterned on the lives of artists such as Vincent van Gogh, Paul Gauguin, Pablo Picasso, and Jackson Pollock. If these men serve as models of the creative personality and the artistic life, then it follows that other models—the craftsman and designer models, for example—are inauthentic or second-class at best.

Returning to Sir Herbert, he regretted the fact that education in the principles of design as they apply to "the typical art of the machine age—is relegated to the technical school."[4] Here he was referring to the strict separation between humanistic and vocational training in England's rigidly stratified social and educational system. In the United States, however, with its ideal of equal economic opportunity and its fairly good record of social mobility, we cannot justify an art education that separates producers from

4 Herbert Read, *Op. cit.,* p. 166.

consumers, workers from managers, artists from critics, and collectors of pictures from buyers of refrigerators.

Nevertheless, we have separated "fine" from "industrial" arts education.[5] This separation, which is scandalous, is reflected in teacher education, in government support, in academic organization, in gender grouping, and in the relations between art and industry. Although commerce has crept into art education more or less surreptitiously, the Beaux-Arts tradition that began in France several centuries ago continues to operate in our teaching. The reasons, to be discussed in the next section, are, in part at least, philosophic.

DESIGN AS ECONOMIC PHILOSOPHY

With respect to an economic philosophy of design, Herbert Read asked the right question: Are the design principles derived from the humanistic (or Renaissance) art tradition compatible with the "essentially abstract" principles that govern mechanical-industrial art? The answer in the United States has usually been ambivalent. Our art education establishment is institutionally and intellectually separate from our industrial arts establishment (although we feel guilty about it). In the larger artworld, too, aesthetics and technics are effectively divorced, which may account for the curiously unsatisfying character of our art and our machines.

We have, to be sure, fudged the aesthetics and/or technics issue by incorporating Bauhaus methods into art education curricula. But these methods are mainly employed to teach formalistic exercises, exercises that are then applied to the design of abstract paintings and sculptures—types of art that eventually find their way into gallery boutiques patronized by well-to-do art collectors.

Our Bauhaus maneuver perfectly illustrates the American strategy of cultural co-optation: we neutralize a philosophy or doctrine by assimilating its principles and using them in a manner that was never originally intended. The Bauhaus, of course, employed abstract design as a means of attacking all previous (and especially academic) modes of making art. That attack belonged to the agenda of socialism. By training students, teachers, painters, sculptors, photographers, and architects in the principles of abstract design, the Bauhaus hoped to transform the language of vision, the tools of artistic creation, the processes of industrial production, and hence the economic and political foundations of society.

Well, the struggle between socialism and capitalism has ended with

5 Irwin Edman makes the point as follows: "The division between things of beauty and things of use is the function of a class heritage and a tradition of industry for profit only." (See Edman, Irwin. *Arts and the Man*, p. 125.)

the triumph of capitalism or, better stated, the triumph of free-market economics. However, the problems of work, art, and technology remain. The conflict between humanistic-design principles and mechanical-industrial-design principles persists—except that old-fashioned machine tools have been replaced by computer-guided robots. The economic consequences are similar: computer-aided design and computer-aided manufacture (CAD/CAM) produce more goods with fewer human operators.

The dehumanization of the process of manufacture has been accompanied by the dehumanization of industrial products and of aesthetic form in general. Ironically, this was the grand reconciliation of art, design, and manufacture that Read foresaw and ardently advocated. Interestingly, he did not regard "formalism" as a bad word; he saw "the purification of form" in art and in industry as a good, even inevitable, development.[6]

Read was, of course, highly sensitive to the sheer boredom of mechanical-industrial work in a technological civilization. For this he saw no solution except automation—a kind of escape—and art education—a kind of compensation and/or enrichment for adults when it is guided by the sensuous apprehension of form, biological principles of growth, and the integration of work and play. In other words, he wanted to restore humanistic principles of art while using abstract principles of design.

Notwithstanding the fundamental decency of Read's vision of art and art education, we can see that it was not radical enough (although Read was all his life a philosophical anarchist). That is, Read's educational strategy was an *accommodation* to conditions he correctly predicted as an art historian but could not avert as an art educator—namely the separation of technics and aesthetics, the divorce of art from work, and the degradation of human effort in the production of the world's goods.

From this brief analysis, it should be clear that design principles are easy to teach in isolation and easy to learn without reflection. The hard part is to see and understand their connections to human perceptual, social, and economic activity. Herbert Read's heroic endeavor to make those connections clear and meaningful deserves our highest admiration. Criticism of his solution does not mean that we presently have better answers; if anything, we are more perplexed than ever. However, there are some principles that can guide our search for better answers.

First, we cannot surrender the distinctive feature of art education which originates in human sense perception and culminates in human forming activity employing the human equipment we have received through our biological evolution and our cultural history.

Second, we are not Luddites, which means that we have no wish to destroy machines, factories, robots, or manufacturers of computer soft-

6 See Read, Herbert. *The Redemption of the Robot: My Encounter with Education Through Art*, pp. 144–172.

ware. At the same time, we should resist the impulse to make gods out of machines, TV sets, fiber-optic highways, or giant computer internets. That was Marshall McLuhan's heresy.

Third, we should apply our best intelligence to the problem of deciding what machines, robots, and computers do well compared to what human hands do well or better. This problem cannot be faced, much less solved, without the experience of making art with our hands and studying art from a critical and world-historical viewpoint.

Fourth, we should consider our discipline, art education, as a continuous investigation into every mode of making such that its materials, processes, and products can be brought together under the rubrics of meaning and pleasure for workers and users.

Finally, we must learn to see every art-making activity as an embryonic industrial activity. We should think about art and economics in a manner that makes them conformable to Kant's categorical imperative: "Act [in our case, think and make] so that the maxim [of our action] would at all times be suitable for a universal law."[7]

THE FUTURE OF WORK

According to Marx, bourgeois production seeks the increase of "exchange value" or profit, whereas communist production seeks the production of "use value"—the satisfaction of workers' needs and the enrichment of their lives. As mechanization accelerates, profits grow larger because labor costs are reduced; better machines minimize the value of the worker's contribution to production. Workers watch helplessly as their skills are sucked into the machine and they become commodities which are almost indistinguishable from the raw materials machines feed on. Thus, the humanity of workers is degraded and the quality of their lives grows ever more dreadful.

Assuming that this analysis of work is correct with respect to the earliest phases of the Industrial Revolution, does it have any relevance to work in the present era, the era of the Computer Revolution? How has labor-saving technology and, especially, the perfection of robots and digital computers changed work and the human role in production? What are the consequences that more and better computers equal fewer employees working at greater distances from the process of making? Finally, do our answers to these questions have any bearing on the role and meaning of art education?

In answer to the first question—Has the computer revolution liberated today's workers from the process of commodification that Marx described?—we can say that workers' wages and security are better. But if we

7 Immanuel Kant, *Metaphysic of Morals*, 1797.

look at an army of computer operators in a large insurance company or in a giant post office sorting room, it is plain that the drudgery goes on. The work environment—light, noise levels, air quality, safety equipment, and so on—is clearly better, but the opportunity to exercise human skills and judgment is worse. As for the exercise of human physical and sensory capacities, it is greatly diminished. We have to conclude that while today's working conditions are much improved, the process of worker commodification goes on.

Our second question asks: How has the perfection of the computer affected the *value* of the worker's role in the process of production? Well, it has eliminated many workers who performed routine mechanical operations. Those who still have employment—in an architectural office or an aircraft engineering plant, for example—function at fairly high levels of abstract decision making. Their training is more expensive and their wages are higher than under earlier systems of production. As to their satisfaction in work, however, it requires a protracted wait before it is realized in experience. Work processes have become increasingly cerebral and symbolic, and if there is pleasure in the products of work, it is a new and different pleasure: today's workers need an enhanced capacity to postpone gratification.

To the extent that work products are read about in a printed report or visualized on a screen, their imagery is somewhat weak from the standpoints of dimensionality, tactile quality, and natural contextual relationships. Computerized forms tend to look mechanical and they are invariably hard-edged. As for color, it can be strong but it is rather raw and unsubtle. Indeed, the array of sensory qualities in today's work products and work settings is either gross or aesthetically anemic compared to the sights, sounds, and smells one would encounter in an ordinary preindustrial woodworking shop.

As to the *value* of the modern worker's role, it has been greatly increased if we employ the economic concept of *productivity* to measure that value. But if we employ an aesthetic concept of *quality*, that is, intrinsic satisfaction in the processes and products of making, then the value of work has considerably diminished.

Now to our third question: How is work affected when those who make production *decisions* operate at an increasing distance from the camera eyes, electronic sensors, and automated forming tools that actually *make* things? Today we have a situation in which workers—even those who are lowest paid—have less and less contact with the substances that constitute the reality of nature, the material stuff of our planet. We witness the logical culmination of the early twentieth century mass-production process: the division-of-labor principle converges with robotics (the science of mechanical serfdom) to create major gains in efficiency together with an almost complete depersonalization of work processes and products.

This depersonalized development, incidentally, was anticipated by the Minimalist sculptors of the 1960s: an artist could *telephone* instruction for making an artwork to a metal-fabrication shop which might be many miles distant from his work space and/or think place. The sculptor did not *execute* the work, and did not see it usually until it was installed in a gallery. Naturally, the *form* of such a sculpture—by Donald Judd, Ronald Bladen, or Robert Morris—had to be consistent with its method of making; it was unnecessary for the artist to examine the work personally to make adjustments of size, shape, and surface quality during the processes of fabrication. The essence of the creative act was the *conception* of the object—an almost wholly cerebral process.

The industrial counterpart of the Minimalist creative process is well known: an automobile model can be planned in Japan, designed in Italy, machined in Mexico, and assembled in Tennessee. The result is thousands of identical cars which can be displayed and sold for about the same price throughout the world. Computer-design and telecommunication make this process of standardization possible and largely error-free: designers, engineers, and fabricators are continuously aware of each other's contribution. That is, they read computer printouts, or they "see" computer-screen displays of everyone's contribution to the overall task. Notice the word "overall": a system, not a person or (God forbid!) an artist governs the process. Manufacture climbs (or descends) to the point where taste, imagination, and judgment can be tolerated only at the "styling" stage of product development.

Believers in progress, we do not regret the fact that traditional artistic functions have been dispersed into teams of managers, accountants, computer operators, and robots. Still, the traditional artistic functions cannot be engineered out of existence. What are they? (1) An organic connection between conception and fabrication; (2) a direct and personal linkage between maker and user; (3) immediate and spontaneous correction and redesign of a product in the light of multisensory feedback; and (4) unified control of process and product exercised by a single human personality.

We can expect that computers, robots, and artificial intelligence machines will continue the endeavor to simulate traditional artistic functions in the production of goods. We can also predict that they will be unable to reproduce the fully human beings who make, use, and cherish goods. Biotechnicians can *clone* creatures that resemble humans, much as agronomists can "manufacture" prize heifers and bull calves; but only education—the systematic transmission of human skills, values, and history—can "reproduce" the *qualities* that enable us to make goods worth using and lives worth living.

We come now to our final question: How does the analysis of modern work affect art education? To some extent art education is a "holding operation" in that it preserves ancient (some would say "obsolete") modes of

production and appreciation. Well, obsolete modes of production remain valuable if we believe modern modes of making and understanding are less than they could be. Separating people from work with their hands and eyes does not appear to be a desirable change in the human condition. Likewise, reducing human experience to second-hand encounters with reality would not appear to be a satisfying consummation of our adventure on this planet.

Beyond preservation and conservation, art education has a responsibility toward the *evolution* of work. Accordingly, we must continuously examine every new instance of making, expressing, and communicating with a view to judging its *immediate and intrinsic* value. That judging should be guided by the standards of our discipline—art—which refuses to separate production from consumption, process from product, makers from users. Of course, economists and technologists can make claims about the benefits of new patterns of production and/or consumption, but someone has to test their claims in the crucible of experience. We and the public need to know whether a process of making is good or bad *now,* for ourselves and for those we teach.

Art education is rooted by its nature in present experience. Dewey made this point for us in 1918 when he said: "Art, in a word, is industry unusually conscious of its own meaning."[8] I take this statement to have multiple significance: First, without work there is no art; second, without meaning art is *only* work; third, the value of meaningful work resides in the present; fourth, meaning is meaningful for humans, and humans alone.

CONCLUSION

Following are some of the terms which have been treated explicitly or inferentially in this chapter. They are presented here as propositions or guides rather than rules or laws. Their purpose is to help us to grasp the economic dimension of a philosophy of art education.

Economic and artistic definitions of *value* converge insofar as they center on the creation and enjoyment of goods. They differ in that artistic creation is usually considered an *intrinsic* good or value, whereas economics deals with *extrinsic* goods and values. Economic activity contemplates a market, so it is concerned with an entity larger than the artist's or producer's self. We may say that the economics of art education requires students to become aware of the extra-personal gains and losses in all forms of creative production.

Economic production and *artistic creation* can be considered two ex-

8 See Dewey, John. "Culture and Industry in Education," *Teachers College Bulletin,* p. 17.

pressions for the same thing, although art educators may think they are po-
lar opposites. If we use Reisman's terminology, art is more "inner-directed"
while economics is more "other-directed."[9] From the standpoint of a phi-
losophy of art education, these polarities represent the actual as opposed to
the ideal state of affairs. In a good society all work would be interesting, all
products would be useful, and all consumption would be satisfying. How-
ever, personal satisfaction would not be at the expense of the collective
good. Thus, a major goal of art education should be the reduction of ten-
sions between economic production and meaningful or satisfying con-
sumption.

Economic consumption and *aesthetic appreciation* can also be con-
sidered different expressions for the same thing. In an ideal state of affairs
they would not conflict. For art educators, appreciation extends beyond
recognition of artworks, identification of their creators, and ability to rank
them according to estimates of their current prestige and exchange value.
Although exchange or monetary values are transcended by aesthetic values,
they are curiously related. In the long run, aesthetic value is a fairly reliable
predictor of pecuniary value. In the short run, Gresham's law obtains:
"bad" money drives out "good" money.

The *property* concept of art is not innate; it is taught. For children, at
least, art is an expression of power or delight; it is a means of communica-
tion before it is a possession or a *commodity* to be traded. The *ownership*
of an artwork, which means holding title to the product of someone's labor,
does not necessarily equate with knowing the authentic meaning or value
of that work. Enlightened knowledge, appreciation of art's goodness and
significance, requires tutelege. Knowing the value beyond the price of any
good calls for critical experience plus aesthetic education.

Marketing or promoting the flow of goods relies on *product aesthet-
ics* to generate *demand* and expedite the sale or transfer of goods to con-
sumers. *Appearance design* (sometimes called *styling*) is one means of
accelerating the flow of goods; another method is *display design* or point-
of-sale promotion. The best-known method of selling and promoting
goods is, of course, *advertising*. Here product aesthetics is combined with
optical stimulation to create *visual appeal*. Art education has not yet de-
vised curricular strategies and instructional materials to cope with these
modes of economic activity.

Quality in art can be equated with *added value* in economics. In the
marketing of goods, quality may involve such factors as costly materials,
difficult modes of fabrication, limited production, restricted distribution,
and invidious considerations of price and prestige. The decease of the artist
or maker is also significant: a dead artist cannot increase the supply of a
unique type of goods or values. In art education, the economic determi-

9 See Reisman, David. *The Lonely Crowd.*

nants of quality are usually subordinated to psychological criteria such as originality, ingenuity, and spontaneity. As for *aesthetic* quality, it is something like pornography: we can't define it but we know it when we see it.

REFERENCES

BANHAM, REYNER. *Theory and Design in the First Machine Age,* 2nd ed. New York: Praeger Books, 1960.

BAYER, HERBERT. *Bauhaus: 1919–1928.* New York: Museum of Modern Art, 1976.

BLAUG, MARK, ed. *The Economics of the Arts.* London: Westview Press, 1976.

BROCHMANN, ODD. *Good or Bad Design.* London: Studio Vista, and New York: Van Nostrand Reinhold, 1970.

CHERMAYEFF, IVAN, et al. *The Design Necessity.* Cambridge, MA: MIT Press, 1976.

DEMING, W. EDWARDS. *The New Economics of Industry, Education, Government.* Cambridge, MA: Massachusetts Institute of Technology, 1991.

DEWEY, JOHN. "Culture and Industry in Education," *Teachers College Bulletin,* no. 10, March, 1919.

EDMAN, IRWIN. *Arts and the Man.* New York: Mentor Books, 1949.

EWEN, STUART. *Captains of Consciousness: Advertising and the Social Roots of the Consumer Culture.* New York: McGraw-Hill, 1976.

FELDMAN, EDMUND B. *Thinking About Art.* Englewood Cliffs, NJ: Prentice-Hall, 1985.

GIEDION, SIEGFRIED. *Mechanization Takes Command.* New York: Oxford University Press, 1948.

HARVEY, JOHN J. *Medieval Craftsman.* London: Batsford, 1978.

HUGHES, ROBERT. "Sold," *Time Magazine.* November 27, 1989.

JOHN PAUL II. Encyclical: "On Human Work," excerpted in *The New York Times,* September 16, 1981.

KLINGENDER, F. D. *Art and the Industrial Revolution.* Chatham, England: Evelyn, Adams & McKay, 1968.

MARTORELLA, ROSANNE. *Corporate Art.* New Brunswick and London: Rutgers University Press, 1990.

MAYER, MARTIN. *Madison Avenue, U.S.A.* New York: Harper & Brothers, 1958.

MEYER, ALFRED C. *Marxism: The Unity of Theory and Practice.* Cambridge, MA: Harvard University Press, 1970.

MEYERS, WILLIAM. *The Image-Makers: Power and Persuasion on Madison Avenue.* New York: Times Books, 1984.

MORRIS, WILLIAM. *On Art and Socialism: Essays and Lectures.* London: John Lehmann, 1947.

MUMFORD, LEWIS. *Technics and Civilization.* New York: Harcourt Brace, 1934.

PAZ, OCTAVIO. *In Praise of Hands.* Greenwich, CT: New York Graphic Society, 1973.

PEVSNER, NIKOLAUS. *Pioneers of Modern Design from William Morris to Walter Gropius.* New York: Museum of Modern Art, 1949.

READ, HERBERT. "Art Education in the Industrial Age," *Art and Industry.* London: Faber and Faber, 1934.

READ, HERBERT. *The Redemption of the Robot: My Encounter with Education Through Art.* New York: Trident Press, 1966.

REICH, ROBERT B. *The Work of Nations.* New York: Knopf, 1991.

REISMAN, DAVID. *The Lonely Crowd.* New Haven, CT: Yale University Press, 1950.

SERLEN, BRUCE. "Projecting an Image—You Are What You Buy," *The New York Times,* February 12, 1989.

SPAHR, WALTER E., ed. *Economic Principles and Problems.* New York: Farrar & Rinehart, 1940.

THEROUX, PAUL. "Money and Art," *Harper's Magazine,* September, 1982.

VEBLEN, THORSTEIN. *The Theory of the Leisure Class.* New York: Macmillan, 1899.

WALLACE, WILLIAM E. "Michelangelo, C.E.O.," *The New York Times,* April 4, 1994.

WATSON, PETER. *From Manet to Manhattan: The Rise of the Modern Art Market.* New York: Random House, 1993.

THE POLITICAL DIMENSION

INTRODUCTION

Art teachers are political animals, but there is some question whether we recognize the political dimension of our teaching. We know that "politics" affects the allocation of funds in a school system—for salaries, equipment, art supplies, administrative services, and so on. These allocations are surely influenced by political considerations, with "political" understood in a less than flattering light. But if we want to understand "political" in a philosophic sense, if we want to know whether art teaching possesses a *power* dimension, then we must set aside the "bad" idea of politics—returning favors, rewarding allies, and punishing adversaries.

Of course, shady practices in politics exist, not because politicians are greedy, self-serving, or lacking in vision. Indeed, many of them have a vision, which is to hold office by helping their friends. There may be a certain nobility in that vision. Noble or not, the ability to help one's friends depends on the possession of power. However, politicians are not born powerful; power is conferred on them. Then where does it come from, and how do they get it? These are questions political science tries to answer. For us it is enough to say that power—in its crude, subtle, and even invisible,

forms—is created by society, that is, by people bound together in associations and institutions where, presumably, they work to advance the common good.

Surely, art teachers can be counted among the societal groups that work to advance the common good. In the course of that work they create some of the stuff of power—the values that politics tries to apportion wisely. In other words, the products and processes of art education are politically important as well as aesthetically potent.

Apart from the ideological meanings of specific artworks, there is a sense in which the structure of our discipline—the who, how, what, and why of art teaching—possesses a political dimension. For that reason, this chapter examines the conventional categories of politics in the hope of discovering their connections to art education, here regarded as a source and mode of exercising power.

AUTHORITY

Authority is what gives a teacher the right—the technical, intellectual, and moral right—to teach. What is an art teacher's authority? In the most obvious sense it is the license or certification awarded by the state on the recommendation of a college or university following a person's completion of an "authorized" program of study. That license is important, but it is essentially what it looks like—a piece of paper. Here we want to know what an art teacher's license really represents. That is, what does it mean to its holder, to fellow teachers, to students and their parents, and to the community at large?

An often overlooked but necessary meaning of a license is the ability to use specialized materials and equipment—anything from paint, brush and canvas to catalogs of art supplies, art texts, films and reproductions, video disks, carousel projectors, and the classification system of a slide collection. For the holder of an art-teaching license these are basic tools; for a school administrator they signify the ability to meet a class; for fellow teachers they stand for professional expertise; and for students they represent a mystery. In any trade—and especially the art teaching trade—tools embody authority; they are signs of serious intent and, perhaps, of competence.

Authority in a political sense is also conferred by a professional code, a statement of the beliefs and educational objectives to which one subscribes, usually by belonging to a professional association. A code can function as a public-relations statement, as a reeducation device for teachers, or as a standard against which the performance of teachers and the effectiveness of their programs can be measured. A code may also have the force of "guild" regulations, which is to say that nonmembers of our asso-

ciation cannot be depended on to teach well. Why? Because they are not publicly committed to our code. Obviously, there are important exceptions to this proposition; nevertheless, a code offers protection to the public because teachers try to live up to its aims and standards. Knowing this, the public tends to trust the code, which makes it a legitimate source of authority.

A third kind of authority is cognitive or intellectual. It refers to what a teacher knows (theoretically, historically, and technically) about art. Sometimes that knowledge is ascertained by formal examination; sometimes it is assumed. Of course, it is easy to know more than students; one can be an expert to them. But this sort of expertise is personally and politically risky: we can be "caught" or "found out," and then our authority collapses; we will be disbelieved even when we are right. The best practical advice here is to admit that we do not know, if that is the case, and devote ourselves to learning as much as we can about art. Knowledge of a related discipline, psychology, for example, can be valuable, but art teachers are rarely considered authoritative in that field; psychologists have guild regulations, too.

Moral authority is the highest type of authority, even in a political sense, because it inspires belief and readiness to act. In its simplest sense, moral authority alludes to what we will not do as teachers. We will not teach bad technique or give incorrect information about art. Beyond that, moral authority means that students trust us because we will not require them to (1) make anything we would not make, (2) know something that we disbelieve, or (3) ask them to feel an emotion or assent to a proposition that violates their dignity as human beings.

What is the basis of a student's trust in a teacher's moral authority? It can be that teacher's age, credentials, reputation, or charisma. But these bases, while sometimes relevant, are philosophically insecure. The ultimate foundation of an art teacher's authority is, and should be, *the teaching itself*. This means the goodness of a teacher's instruction, not as it is defended or justified on paper but as it is manifest in the student's work, as it is felt by students in their immediate experience, and as it is understood by students in its implications for humanity and the world they live in.

Real authority in an art teacher cannot be reduced to a personality trait, it is not conferred (except in a bureaucratic sense), and it does not mean infallibility. It is an earned status given by students to a teacher who has (1) shown them how to make wonderful things, (2) taught them to speak in a language they did not know, (3) introduced them to the world as art reveals it, and (4) explained the similarities and differences between the real world and the artworld in a manner that seems to them plausible.

POWER

Power is related to authority but it is not the same thing. Authority may begin as a legal empowerment, such as a teaching credential, but ultimately it is a personal attribute. Thus, I can teach watercolor painting in the schools (if I have a license) but my teaching has no real authority until my students believe they paint well because of my instruction. Power, on the other hand, refers to sources of influence outside a teacher's knowledge, personality, and pedagogical skill.[1] Perhaps power in our profession is best defined by the answer to one major question: What makes art potent in teaching?

We can give some answers which are provisionally true. Power is held by school boards, administrators, leaders in the profession, curriculum theorists, authors of art texts, and professors who teach teachers to teach. Power can also be ascribed to certain key disciplines, such as learning theory, philosophy of education, cognitive psychology, art history, and so on. There are also institutional sources of power: professional associations of art teachers, accrediting associations, teachers unions, testing companies, state departments of education, federal agencies and endowments, and nongovernment foundations. Acting through their officers and administrators, they can "make things happen," we think. Finally, museums, art galleries, art publishers, and manufacturers of art supplies should not be overlooked. It seems plain that art education is governed, guided, supported, and "threatened" by many institutions and agencies. That is, the power to teach art is highly circumscribed.

But we have neglected the "Wizard-of-Oz" effect. The Wizard who frightened the young girl from Kansas [Judy Garland] was really a silly old man; his power was an illusion. Similarly, the power of art education is constrained only if we take art bureaucrats seriously. They have to "do their thing," but their influence is marginal when compared to the truly operative agency in art teaching. What is that agency? It is the entire body of images created by our species for every kind of purpose; it is the glorious scribble of the kindergartner and the Sistine ceiling of Michelangelo; it is the visual or phenomenal world—not as God made it but as we receive and transform it according to our heart's desire.

If the history of art is defined so that it embraces the crafts, the so-called applied arts, and the arts of design including advertising and information design, and if we include the most recent forms of making and transmitting images, then art has power as political science understands the concept. That power can be described in terms of the inherent capacity of artistic images to (1) stimulate desires, (2) create needs, (3) mobilize feelings, (4) generate attitudes, (5) establish ideals, and (6) change conduct.

1 See my article, "Power in Art Education: Where Does It Come From? Who Are Its Mediators?" *Journal of Aesthetic Education.*

Accordingly, while political theory assigns power to persons, agencies, and institutions, we assign it to the images made by human beings.[2] It is the power of images to influence behavior that makes advertising art so costly. It is the power of images that explains the political struggle to control the canonical works in school and college curricula. It is the power of images that accounts for the enormous prices of a small number of selected artworks, which are made of the same materials as the much larger number of *un*selected works. The power of the selected works (if not their price value) has at least something to do with their visual organization. The power of art is due in no small degree to the way it gains access to the human apparatus for seeing and understanding. Once we *see* an image, it is difficult not to see it; its power becomes irresistible.

Short of physical coercion and threats of force, power is commonly exercised by the images inside people's heads. And those images originate most commonly in art, that is, in visual forms deliberately organized to reach behind our eyes. Images have power not only by virtue of the fact that they exist and are seen, but also because their makers—artists—wish to exert power. Whether they know it or not, whether they admit it or not, artists (including the children among them) make images in order to assert their dominion over reality. As René Huyghe puts it: "Art is primarily an act of taking possession."[3] If "taking possession" means "capturing," and if capturing is the quintessential expression of power, then art is by definition a political activity.

One of the strongest arguments for the power of images in art education comes from child art. Consider the school time spent in eliciting this imagery, the delight it brings to parents, the sense of mastery it gives to children, the learned studies devoted to its interpretation and, finally, its remarkable capacity to legitimate a grade school as a place where children work with their hands, eyes, and imaginations. These are the circumstantial signs of a power possessed by the least of us, the youngest of our species. Alas, its power is fleeting, and much of our pedagogy is devoted to keeping it alive. We wish we understood that power in depth. At any rate, our profession tries desperately to harness it for the education of young people before it is too late.

Just as the highest form of authority—moral authority—resides in the teacher, the highest form of power resides in images—the images created by pupils, the images received from the various historical traditions, and the

2 Consider the corroboration of Jacques Ellul: "What we have now is a universe in which everything is translated into images, in which everything *is* image. Not just the individual fact but the whole fabric of things is translated or transformed into images." (See Ellul, Jacques. *The Political Illusion*, p. 113.)

3 See René Huyghe, *Larousse Encyclopedia of Prehistoric and Ancient Art*, p. 16.

images continuously created in our culture by every device and medium of transmission that we possess—but cannot control.

DEMOCRATIC PRINCIPLES

Art making has been taught and learned in every human group since the Paleolithic hunting band. The democratic state and public education, on the other hand, are very recent phenomena. So also is the notion of teaching art in the schools of a democracy; we are still grappling with the implications of that fact. What are those implications? Do they point to any ideas or principles that can guide instruction? Yes, if only because democratic principles affect our notions of what art is, who can study art, and who is qualified to criticize art.

First is the democratic principle that gives rise to our discipline, namely that everyone should have the opportunity to make and study art—as part of a general education, as preparation for a profession, or for personal enlightenment and pleasure. Today we take this opportunity for granted, without realizing that in predemocratic societies aesthetic education was a privilege of the few, while the professional study of art was restricted by gender, class, and family tradition.

A second principle is that everyone in a democracy should have access to the great art of the past, mostly held in museums. Formerly, of course, this art could be seen rarely, if at all, in royal palaces and private collections. Restricted access is still the case in many places, but we know something of the work in major private collections through reproductions and periodic public exhibitions. Here is should be understood that art students need to see great works of art face-to-face, and as often as possible, in order to realize their own potentials. As for the general public, its knowledge is incomplete, its taste is uninstructed, and its aesthetic options are constrained without access to the finest work created in the world's major civilizations and cultures.

A third principle informing the education and politics of a democracy is that plain people are capable of understanding, enjoying, and benefiting from art originally created for the delectation of the upper classes. Even today, this principle is controversial: many art educators simply do not believe it; others think it has elitist, hence odious, implications; and some try to finesse the issue by building their instruction around the contemporary popular arts and ignoring the so-called "high" arts.[4] Here our democratic

4 In principle, popular art has the same aesthetic potential as "high" art, but this does not justify its use as a weapon to *disvalue* high art. Sometimes, the art of kings is inspiring and good, while popular art can be monotonous, or, worse, downright vicious.

pretensions are tested: it should be an article of faith that every kind of art is potentially meaningful to every one of our students. The best is not too good for any of us.

Our fourth principle is an interesting corollary of the third, namely that the interpretations, judgments, and aesthetic preferences of ordinary people are not to be disdained because of their class origins. It is the goodness of the judgment, not the status of the judge, that counts. Hence, art educators should not see themselves as missionaries whose purpose is to convert the lower orders to the opinions and tastes of their "betters."

A fifth principle derives from the pedagogy of the Bauhaus, perhaps the most revolutionary art education experiment of the twentieth century. It maintains that there should be no hierarchy of aesthetic value among the various materials, media, and genres of art. Accordingly, and in principle, a book illustration is as good as an easel painting, a wood carving is as good as a bronze casting, a watercolor is not inherently better than a photograph, and a good pot is worth as much as a good print.

Beyond these principles, a democratic art education encounters special problems in the fact that the art professions are professions of excellence; no one sets out to be an average or mediocre artist. To be sure, most grade-school pupils have not decided to become art professionals, while some high school students decide on an art profession even when they have no apparent aptitude for it. (And some succeed despite their apparent lack of aptitude.) In general, however, our democratic ideology leaves us frustrated when we encounter weak artistic motivation and less-than-good artistic performance: Have we failed as teachers? Are we blind to certain types of creativity? Have new artworld developments made our aesthetic judgments obsolete? Does some dark prejudice lie behind our opinions about "talent" and "giftedness?"

There appears to be an honest and a dishonest way to deal with these dilemmas. The dishonest way is to define artistic excellence so that it fits whatever a student makes. The honest way is to conclude that every child of God is good at something—not necessarily art—and the task of a teacher is to find out what that "something" is and then build on it. That would be a more principled position for an art teacher who is, after all, an art professional capable of distinguishing between the good, the mediocre, and the bad. Our maxim ought to be: A democratic education through art but without deceit.

For some educational theorists the *processes* of art instruction exemplify a kind of democracy-in-action. In the evaluation of studio projects, for example, it is not unusual for an art teacher to invite the opinions and reactions of the whole class. This kind of teaching represents an acknowledgment of three democratic ideas: (1) a work of art created under school auspices is intended and destined to be seen by the public; (2) the value or effectiveness of an artwork is substantially determined by the responses it

elicits from persons other than the artist; and (3) a student's artwork is judged, in the first instance, by a "jury" of his or her peers.

Another democratic feature of art education emerges in the classroom teaching of art criticism: it is largely a collective process. The personal, even idiosyncratic, observations of students are tested *in public*. Interpretations are made on the basis of evidence that *everyone* can examine. Students are faced with a *common* problem (the work of art), and they cooperate by building on *each other's* discoveries of visual facts and relationships. Following Dewey's principle that the school is an "embryonic community," the cooperative conduct of art criticism in a classroom setting represents a model and practical demonstration of democratic problem solving.

PUBLIC OPINION

In addition to images and objects, and students and colleagues, every art teacher works with public opinion. One cannot teach effectively without an awareness of the matrix of ideas and attitudes that feeds our students; they bring public opinion to class along with their head sets and school supplies. Then, after they leave us, they carry our instruction back to their jobs, families, and communities. This is the "secondary effect" of teaching; it enters the public domain and becomes the primary stuff our colleagues have to contend with.

The art educator's interest in public opinion and public taste (which filters into arts policy at all levels) is both altruistic and selfish. Altruistic because we hope the recipients of our instruction will go on to have a positive influence on society—an influence leading, for example, to better public architecture, improved community planning, and less visual pollution on the places where people congregate in large numbers. Our motive is also selfish because these happy outcomes would make it easier—at least more interesting—to teach art.

But while avowing an interest in public opinion, we disavow an interest in manipulating or "brain-washing" the public. Our prior commitment to democratic principles means that we want the public to choose the good because it *prefers* the good.[5] Here again, we have an altruistic and a selfish motive. Altruistic because we believe the desire for excellence in art is a good thing, and because a decent visual culture is inherently better if it is freely chosen. Our motive is selfish because we work in an artworld that reflects the general culture of our citizenry. When bad art is celebrated, the aesthetic climate is hostile, art teaching becomes more difficult, and the quality of life is debased.

5 There can be no doubt that the public in a mass democracy prefers and consistently chooses excellence in sports. Why not in art?

Art educators cannot afford to ignore public opinion, here under-
stood as the taste of the majority, or the so-called "masses." After all, we
are partly responsible for that taste. When we are not its main corrupters,
when the public's taste is ruined by others, it is still galling to witness the
spectacle. At this point, the politics of a democratic art education emerges
in high relief: those who teach art are as much involved in the perversions
of public taste as the bad artists, unscrupulous dealers, noisy hucksters,
and happy schlockmeisters who infest our culture. That is, we have to con-
cede that the hucksters and schlockmeisters were once our students.

Does it follow from these observations that we have failed to teach
"good" taste? No, because that should not be done in the first place. Also
because teaching good taste is virtually a guarantee that bad taste will pre-
vail. Experienced teachers know that art advocacy breeds defiance: stu-
dents tend to dislike what their elders love; generational conflict is virtually
the governing principle of stylistic change and the aesthetic prevailing at
any given moment.

With respect to the improvement of mass taste we face a *political*
problem: How can a relatively small number of art specialists, working
within a large but not-very-powerful profession, successfully oppose, and
in time overcome, the noxious influence of a visual culture propagated by
clever persons with almost infinite resources of money and technology?

The answer is that we cannot prevail by adopting the images, tactics,
and aesthetic preferences that we wish to supplant. And since we do not set
out to teach taste as such (that would be indoctrination) we try to provide
students with *alternatives* of taste from which to make choices, as is their
democratic right. This policy is analogous to the advice given physicians in
the Hippocratic Oath: If you cannot cure a patient, at least do no harm. For
art educators that counsel might be stated as follows: If you cannot per-
suade students to enlarge their range of artistic affections, do not at least
pander to their Philistinism.

Enlarging the affections or tastes of students means making alterna-
tives of form, expression, and meaning emotionally and cognitively acces-
sible to them. That is the art of the art teacher, not preaching, not noisy
advocacy, and not whining about the awfulness of the student subculture.
We have to operate on the assumption that their dismal choices are based
on ignorance, lack of opportunity, or bad teaching from unnamed sources.
The idea is to show them something better.

Does that "something better" exist in the realm of art? Of course it
does. Any one of us can testify to the immense power and enduring value
of an image by Michelangelo, Lautrec, or Kollwitz. Can a Lautrec hold up
against a frame from *Beavis and Butt-Head?* Can a mother by Kollwitz
hold up to one of Madonna's lubricious photographs? Can Michelangelo's
Adam contend with the *Playboy* centerfold exhibiting Burt Reynolds' bi-
ceps? It has a chance.

The public's taste can be changed by teachers who have the right tools and the will to use them. Although the mass media are rich, powerful, and ubiquitous, they possess nothing as strong—ad *durably* strong—as the images created by Michelangelo, Lautrec, and Kollwitz. We have only begun to exploit the power of these images in our teaching. When students have experienced that power, they will be unwilling to settle for less.

LEADERSHIP

Leadership follows authority, power, public opinion, and so on, because it depends on all of these things. After much theoretical talk about the politics of art education, it is leadership that must "put it all together." Teachers may have something to teach and pupils may be eager to learn, but we need leadership to organize their coming together for the sake of an overall educational purpose. That, at least, is the theory.

Here I propose to examine art education leadership as an honorable calling, as work that someone has to do, and as a subfunction of a large category called "the business of getting results through the efforts of others." That requires us to ask certain fundamental questions: What is leadership in art education? Do we need it? Is art leadership different from other kinds of leadership? Are some people "born leaders" or do they just get that way? And finally, if leadership is necessary, how do we know whether it is any good?

First, what is an art education leader? It is a person sitting on a three-legged stool, with each leg resting on a different kind of terrain. The terrain under the first leg consists of logistical and bureaucratic stuff—art supplies, art room facilities, class schedules, state department directives, memos from high officials, and meetings with fellow administrators—*endless* meetings. The second leg stands on more nearly human ground—art teachers, nonart teachers, guidance counselors, curriculum specialists, and students regarded as aggregates of needs, desires, problems, and possibilities. The third leg is the discipline of art education itself, represented by its numerous publications, model curricula, professional meetings, job-alike colleagues, friends in the trade, former teachers, memories of artistic experience, and the flood of news and propaganda that issues from the weekly and monthly art press.

Second, do art teachers need leadership? This is like asking whether artists need dealers and critics. Of course art teachers need leaders, if only to act as intermediaries between themselves, their students, and their discipline, on the one hand, and a hostile, querulous, or indifferent public, on the other. To use a sports analogy, teachers need leadership to "run interference" for their programs, which implies that art education leaders have to take a certain amount of battering, or else learn to "roll with the punches."

Third, is art leadership different from other kinds of leadership? No, insofar as it requires the character traits and human relations skills we would expect of anyone with a modicum of authority. Yes, insofar as art leadership seeks educational outcomes which are at once similar to, and different from, the outcomes of other kinds of instruction. Here the American conviction that leadership is management, and that management is a science which can be applied to any activity or subject-matter, has caused a great deal of mischief.

As to our fourth question—Are leaders born or made?—the correct answer is "both." Here we need not become involved in the nature and/or nurture controversy. One thing seems certain: every type of leadership—from innovative to plodding, from brilliant to half-bright, from charismatic to plain dull—has probably benefited from experience. In the case of art leadership, we expect that experience to be authentic, that is, valid by virtue of serious involvement in the practice or study of art, preferably both.

The answer to the final question—How do we know whether our leadership is any good?—takes up the rest of this discussion. The problem is difficult to solve because it involves the evaluation of motives, methods, and goals. There is an immense literature on leadership and related topics such as supervision, administration, management, guidance, and the several sciences of punishment and reward. We shall deal with these topics mainly as they relate to art education.

Motive and Attitude

The principal motive of art leadership ought to be the pleasure of building and sustaining a good art program, not only on paper, not necessarily a large program, and not always a spectacular program. Certain qualities or attitudes should accompany this motive: patience, a focus on long-term objectives, ability to tolerate short-term foolishness, a passion for excellence (plus the flexibility to accept a little less), eagerness to give credit and express appreciation *in public,* willingness to consult combined with readiness to accept responsibility, firmness (but not rigidity) in making decisions, a desire to be liked (plus a determination to be fair), and the ability to be serious while not taking one's self too seriously.

Method and Technique

The main method of leadership is reinforcement, that is, praise and reward for the achievement of objectives that have been jointly developed and operationally defined. In art education this requires the collective production of *images of excellence* in teaching and in students' artistic performance and discourse. These "images" should be clearly understood, broadly accepted, and publicly recognized when they come into view.

Inspiration, the second method or technique of leadership, depends not so much on charisma (which can be very trying) as on the ability to *revive and continuously redefine* the images of excellence mentioned. This is our great defense against monotonous performance, teacher burnout, and system-wide loss of affect.

The third technique of leadership is itself an art form; finding and cultivating sources of outside support. High administrators usually believe in praise that comes from outside. It constitutes *evidence* of excellence, and when accompanied by funds it constitutes *proof* of excellence.

A final and desperate method of art leadership is the conduct of a continuing program of aesthetic education for other administrators, preferably in the late afternoon when they are not feeling tense. That program should not resemble a college course, it should employ little or no paper, and it should not be spoiled by lectures. It should consist largely of viewing art images, by the masters and by kids, from all the great cultures, beautifully reproduced, displayed with little comment, and followed by coffee and cake, some good talk, and an early return home.

Goal-Setting

Without vision the people perish; without goals there is much noise and commotion and very little progress. Being able to set goals—goals that are attainable, defensible, challenging, and cost-effective—is the great test of art leadership. Goal-setting may not be the "sufficient cause" of outstanding art leadership, but without it good teachers are likely to flounder.

A goal statement can be written down, illustrated, printed, and distributed. What matters is that it be the product of a particular art leadership, working with a particular teaching staff, in a particular school or school district, and intended for a particular student population. Following are some general *desiderata* of a goal statement fashioned by an enlightened art leadership *together* with the teachers who must make it real.

- Attitude comes first. A goal statement should be written with the expectation that it will have to be put into practice, by ourselves or a colleague we care for.
- The best goals will be comprehensible to intelligent nonart people, including principals, parents, high administrators, and public officials.
- The goals of the art program should be logically related to general school and curricular objectives while retaining a distinctive artistic and aesthetic character.
- Art goals should be ambitious and realistic at the same time. They should be acceptable as art education, predicated on reasonable

support, and expressed without undue recourse to hyperbole or jargon.

- Some goals, for example, developmental goals, will be age- and grade-specific; others will apply to special school populations; still others should pervade the entire art program. All goals should be acceptable (in principle) to good teachers of any subject.

- An art-goals statement should be expressed so that teachers and administrators can tell when its objectives have, or have not, been achieved. Obscurantism is one of our besetting sins, so we should use operational language whenever possible, and we should give specific examples with respect to artists, artworks, art processes, and aesthetic concepts.

- Our goals should be responsive to contemporary developments in the artworld and in the world at large, but they should not become obsolete when the headlines change.

- An art-goals statement should possess a quality of organic wholeness; that is, its separate objectives should be related to each other by logic, by sequence, and by a sense of mutually reinforcing parts and processes.

In its totality, a goals statement should be relevant—without exaggeration or painful stretching—to a large moral purpose. *Moral purpose* is both a *political* and *ethical* obligation of genuine art leadership. "Political" because our discipline will not hold its place in the schools if it cannot be seen as part of an enterprise that somehow makes our students better persons. "Ethical" because art teachers are more than technicians; they are also human beings with convictions about right and wrong acts and behaviors. Which means teachers are more effective when their work and their convictions are all of a piece.

POLICY

It must be understood that the ultimate power of art education resides in visual images and the actions that generate them, the images students make and the images they study. But who decides which image-making skills we ought to teach, what media we should use to make art, and what value art has for the education of young people? Also, who decides *which* images we shall study, what is appropriate to say about them, and why some kinds of images are better than others? These decisions—made by teachers, supervisors, curriculum specialists, professors of education, and so on—are the product of a consensus we may call "art education policy."

Our consensus about policy is not fixed, it is not the result of a con-

spiracy, and it is not strictly enforced. Nevertheless, it is remarkable how often art teachers throughout the country make approximately the same decisions at the same time. This may or may not be evidence of professionalism, but it does testify to the fact that a policy-making process goes on continuously in the field. It implies, moreover, that there are professional issues that reflect disciplinary concerns—concerns that policy makers (whoever they are) wish to address.

Here let us define "policy" in art education: it alludes to the *line of practice*, adjusted to the main concerns of our discipline, followed by many or most art teachers, and acknowledged as legitimate by authorities and spokespersons in education, the arts, and government. Our "line" does not always or precisely correspond to our performance; nevertheless, it constitutes the *justification* of our performance. In actuality, each art teacher has a policy of his or her own, and that policy is likely to be a mixture of the following disciplinary concerns.

Technical Concern. Here it is maintained that teaching artistic skills is the principal task of art instruction, especially because it is the goal that parents, administrators, and other teachers most readily acknowledge as legitimate. This goal is reinforced by two powerful factors: (1) the early introduction of art (mainly drawing) into the schools on the basis of its usefulness in training competent industrial workers; and (2) the (mostly) middle-class perception of artistic accomplishment as a sign of cultivation and refinement and hence as a factor in upward social mobility.

Media Concern. This is an outgrowth or extension of technical concern. Advocates of media study—usually "new" media—have grasped a partial truth, namely that the history of art is in a sense the history of new image-making technologies. Accordingly, they are inclined to see the *salvation*[6] of art education in computer art, interactive video, virtual reality machines, fiber-optic transmission, and so on. The immense power and social influence of these technologies cannot be denied; however, art education has not gone far beyond *acknowledging* that power.

Psychological Concern. Here art is considered an alternative and possibly more effective approach to learning for pupils who lack academic motivation or who employ "different" cognitive styles. The cultivation of creativity and creative problem solving is a special feature of policy centered on psychological concern. The absence of solutions known in ad-

6 The notion that the new media are salvific comes to us from H. Marshall McLuhan. For the full elaboration of his philosophy, see Marshall McLuhan, *Understanding Media: The Extensions of Man;* and McLuhan, *Laws of Media: The New Science.*

vance of a student's artistic production is considered a distinctive asset of our discipline. That asset is presumably compromised if curricular time is given to academic studies such as art history and aesthetics. The main goal of art instruction should be the development of mental traits: desired modes of feeling, thinking, remembering, and imagining acquired through "hands-on" art activity.

Historical Concern. Through the discipline of art history, teachers make common cause with advocates of liberal and humanistic goals in art education. The full achievement of these goals is impossible without a knowledge of the principal art-historical traditions and their best exemplars. In addition, art-historical study enables students to build a foundation for making informed judgments about art, their own art and the art of peoples and cultures beyond their everyday experience.

Critical Concern. Here adherents maintain that the command of a systematic approach to art criticism is essential for every student, regardless of artistic aptitude or vocational goal. For teachers of technique, criticism is implicit in the critical concern with artistic quality. For students with professional art ambitions, the ability to examine one's own work intelligently is crucial. For advocates of art education as one of the humanities, criticism opens the door to the world of art and ideas. Criticism cements our alliance with the "liberal" arts, and that lifts us above the "servile" arts.

Social Concern. The commitment here is to art education as a way of encountering the various peoples, classes, and conditions of humankind. In this view, a people's typical traits and characteristic ways of living and working are best understood through its artistic production. Pupils are encouraged to rise above provincialism, chauvinism, and prejudice; they learn to see the world through the eyes of persons *unlike* themselves. Passionately advocated by multiculturists, these cosmopolitan goals are pursued through art-historical and sometimes technical study. It should be added that access to the social values of art requires mastery of critical technique: without criticism the art program becomes a more or less well-illustrated travelogue.

Aesthetic Concern. The term "aesthetic" is widely used in our discourse as a synonym for "purely or uniquely artistic." The term's emphasis is on art as a subject in its own right, a subject capable of serving other disciplines but mainly valuable in and of itself.[7] Among the prime virtues of this

7 The idea of art as a separate subject or discipline is supported by Cassirer as follows: "What [all the aesthetic schools] have to admit is that art is an independent 'universe of discourse.'" (See Cassirer, Ernst. *An Essay on Man,* p. 182.)

policy concern is quality or excellence in art. But sometimes aesthetic concern is understood as no more than a commitment to formalism, according to which the social, political, economic, and so forth values of art are irrelevant. Further complicating the matter, "aesthetics" (in the plural) is confused with "philosophy of art," which is a related but different discipline.

Metaphysical Concern. This is my term for the commitment of a small but dedicated band of teachers for whom making art is a mystical or spiritual quest.[8] Although art requires material substances for its production, its goal is held to be the experience of the immaterial and the ineffable. It is not easy to evaluate this sort of experience, which causes considerable difficulty when we try to make policy and construct curricula. Still, the devotees of art as a mysterious something, which we know when we have felt it, are not deterred. And they are among our most effective teachers. Why? Perhaps they know something that has escaped everyone else.

From this overview of professional concerns—each persuasive in its way—it is clear that art education policy represents a shifting consensus fashioned from the conflicting claims of many partially valid points of view. The consensus we reach may be provisional, but it lasts long enough to generate art curricula that have a certain family resemblance. Those curricula, in turn, shape the teaching that affects what students learn. Which means that an art education policy is more than a public relations statement or a professional adornment: it eventually enters the lives of real people.

Educational policy, like war and government, can be a game played by generals too far behind the lines to know what is actually happening. It would seem that policy makers need an organic connection with the soldiers in the trenches; they need the kind of continuous feedback loop that Edward Deming has used with such conspicuous success in his quality-control movement.[9] First, however, the generals and policy makers must know what quality looks and feels like.

ART ACTIVISM

The school community often treats art teachers as in-house sign painters, corridor and cafeteria muralists, or poster and banner designers for social events. Some art teachers see this as disrespectful of their educational mis-

8 Consider John Dewey's words along these lines: "And when the emotional force, the mystic force . . . of the miracle of shared life and shared experience is spontaneously felt, the hardness and crudeness of contemporary life will be bathed in the light that never was on land or sea." (See Dewey, John. *Reconstruction in Philosophy*, p. 164.)

9 See Deming, W. Edwards. *The New Economics of Industry, Education, Government*.

sion; others convert the jobs into classroom and art-club projects. But annoying as the "requests" may be, they point to the perception of art teachers as specialists in public communication: our colleagues think we are good at reaching the public with a strong graphic message.

What art people know is that letters are more than signs of sounds: they are complex images that have a unique capacity to convey feelings and ideas. Hence the art-class poster assignment is more than a problem in the pleasing organization of abstract letter forms. It constitutes an introduction to the social meaning of graphic communication. If properly taught, students learn that banners, posters, and murals—indeed, most forms of public art—make "big political medicine." These art forms can change loyalties, appeal to constituencies, and build allegiances. Indeed, a poster might be defined as a visual device for "making" people act the way someone wants them to act.

We would like to think that political decisions are the products of much reading, listening, and weighing of evidence; and perhaps that is true for some of our fellow citizens. Still, we cannot be blind to the immense amount of imagery employed in modern political campaigns to *prevent* people from thinking. And when the elections are over, graphic imagery is employed in the work of governance, that is, in the business of visualizing issues, dramatizing values, building coalitions, and making laws.

Signs and emblems started out as simple public announcements, but they evolved into complex and often compelling forms of communication. Thus, the banner began as a plain and frequently improvised information device. The same can be said of the poster, although many posters have become works of "high" (that is, politically indifferent) art. The art educational point is that these relatively unsophisticated devices, these underrated art forms, give students a genuine opportunity to deal with the problems of visual communication and information design. The persuasive power of graphic art makes it a potent instrument of political action.

Defacing street signs and spray painting the walls of public buildings are also types of political action, or graphic activism. Avant-garde galleries have been quick to capture and exhibit the violent imagery of the streets, thus displaying our culture's remarkable capacity for co-optation, converting the symptoms of social pathology into aesthetic fun and games. The talent of art educators runs in a different direction: we may recognize graffiti as public expressions of anger, pain, and resentment, but we try to convert that expression into visual *language*. As angry gestures are transformed into linguistic symbols, they enter the realm of peaceable, that is, civilized, discourse.

Ideally, a school's sign-making projects evolve into humane forms of social and political exchange—endeavors to engage in democratic dialogue through the language of graphic signs and symbols. The first steps toward accomplishing this larger purpose begin with the informal poster and the

improvised banner. Perhaps they constitute shouting in public, but that is our way of celebrating the First Amendment.

PUBLIC SUPPORT

The fierce quarrel over the award of public monies to controversial artists by the National Endowment for the Arts obscures an important fact. The overwhelming number of artists in North America are already receiving public support: they teach in our schools,[10] colleges, and universities. Some call themselves art educators and some do not. All of them teach art for a living.

The public schools have operated an *indirect* system of art support for close to a century if we consider the following facts: art teachers are trained as artists; they represent art in the school and community; and a large number of them are practicing artists on their own time. Much of Georgia O'Keeffe's career followed this pattern; like many artists she taught while creating art for the general public. In many college and university art departments, instructors are expected to be exhibiting artists *as a condition of employment*. This pattern, established as early as 1871 in independent art schools and private universities such as Syracuse and Yale, was adopted by major land-grant universities in the 1930s, from whence it spread through higher education. Its rationale was threefold: (1) the skills, tactics, and strategies of art are best taught by active producers; (2) the university's idea of research should embrace the work of artists (including poets, playwrights, and composers) as well as scientists and scholars; and (3) educational institutions should function as culture creators as well as culture transmitters and interpreters.

Of course, almost all the masters had pupils, and (except for the self-taught) all of them had teachers. The question of public support for art enters the picture when it is the state that pays for the master and/or apprentice or teaching and/or learning arrangement. Notice that while a great deal of art is produced in this way, and while it varies greatly in quality and content, the arrangement generates very little controversy. The public monies expended on art instruction in the schools far exceed National Endowment expenditures, yet taxpayers do not object. Why?

The answers are interesting from a political as well as a cultural standpoint. First, funds for art education are allocated locally. That is, a school system's budgeting process is much closer to the people it affects

10 According to the Director of the Budget of New York State, the state "includes nearly $230 million to help pay the salaries of the more than 10,000 music and art teachers in our elementary and secondary schools." Letter to the *New York Times,* Oct. 22, 1993.

than the somewhat convoluted federal system of grant making, which op-
erates at a considerable distance from the recipients of its largesse. Perhaps
cultural decision making is more acceptable to the extent that it is closer to
the consumers of its products. Second, there is in the schools a face-to-face
relationship between art teachers and the publics to whom they are re-
sponsible: pupils, parents, nonart teachers, school administrators, and peo-
ple in general. Third, the community's involvement in local education
makes it difficult for an art coterie to dominate a school curriculum, much
less a school district. A federal art bureaucracy, on the other hand, can be
captured by a small but determined band of enthusiasts, or given in pay-
ment for an unrelated political debt. Finally, local spending on art tends to
be proportional to local wages and costs of living, whereas federal spend-
ing tends to be guided by the obscene prices prevailing in major art mar-
kets. The distortions of an art market (frequently related to stock market
windfalls) are unlikely to be tolerated in the context of the wages paid for
teaching art in a public school.

This final observation about prices, wages, and markets raises an
overriding question about the politics of public support for art. Citizens
can appreciate the fact that the contract of a basketball star may amount to
several millions over a five-year period—more than the lifetime earnings of
an art teacher. That ballplayer may be so good that he becomes the object
of national—even international—competitive bidding. However, the same
calculus does not apply to the artists whose services the citizenry is being
asked to pay for. Nor is it apparent from the aesthetic evidence that this or
that performance artist is that much better than our local art teacher. In-
deed, citizens (not all of them Philistines) may suspect that they have been
manipulated by art bureaucrats in league with culture-hucksters who have
a strong instinct for the medium of money.

Here the political responsibility of art education comes into focus. We
have to distinguish between aesthetic education and art mongering. The
fact that national foundations and agencies, famous critics and dealers, and
important curators and journalists favor an art personality or an art style
is not necessarily a guarantee of excellence. When judging art and making
decisions about whether or how to support it, we might think of it as food:
we need to taste it ourselves to decide whether it is any good. This demo-
cratic principle applies to our aesthetic "vote"; no one can cast that vote as
well as we can.

THE LIMITS OF POLITICS

Art teaching takes place in institutional settings, so it is inevitably affected
by political forces. For this reason there is a tendency to think of art edu-
cation as itself a political enterprise. That is, instruction is considered a

power maneuver, learning is regarded as a response to power, and art is understood as a display of power relationships.

Because the art and/or power nexus has some foundation in reality, it is possible for art education to lose sight of its aesthetic character and disciplinary center. For example, a child's drawing may express the wish to exert power over persons, places, and objects; however, that does not tell the full story of the child's drawing. Art teachers may be required to follow state-approved curricula, and their performance may be subject to evaluation by principals and supervisors; nevertheless, the autonomy of teachers with respect to thematic materials and classroom tactics is still considerable. A great work like David's *Death of Marat* may be studied for its political meaning, but it is possible to examine that painting on technical and stylistic grounds. The political significance of art and art instruction does not exhaust *all* the meanings of art and art instruction.

In practice, the political potential of art instruction may or may not be exploited, depending on the teacher's commitments, predilections, and professionalism. I believe the outcome hinges on the teacher's professionalism.

The question of an art teacher's political commitment is easily settled. Any teacher would be an incomplete person if he or she had no convictions about current legislation, economic policy, foreign affairs, and so on. Those convictions can easily find their way into his or her instruction. However, a teacher's politics should never be the primary and deliberate focus of instruction; nor should the *magisterium* of education, the authority of the teacher, be used to convert students to the teacher's politics.

Sometimes, of course, one's political ideas appear to be so enlightened, so self-evidently true, that it seems wrong—intellectually and morally wrong—to set them aside in class. This results from adopting an evangelical stance in teaching. But that stance falls apart when we consider how it might be employed by someone with whom we disagree—say a teacher who proselytizes for creationism in biological science, spiritualism in physics, ethnocentrism in social psychology, or the shedding of real blood in performance art.

Nor is the problem of political limits solved by giving equal time to every point of view. All points of view are not equally valid. And even if they were, time is limited, attention spans are short, and lessons can easily lose focus.

We come down, then, to the art teacher's professionalism, which urges us to remember three things. First, our expertise and teaching authority are necessarily based on what we know well and can do best. Second, the equation of a visual form with a political idea is often due to a confusion of categories. Third, good teachers ought to observe these critical principles: one does not *impose* political meanings on works of art. The work declares its intentions and tells us how it wants to be understood. Where there is political significance, we make it known; where it is not, we

do not. Finally, it is best for students not to know where their teacher stands politically: let them guess.

CONCLUSION

Following are some definitional statements about the main terms used in this chapter, together with my observations about their meaning for art education.

> The *political power* of art derives from the *psychological potency* of visual images. The *authority* of art teachers derives from their skill and effectiveness in deploying those images. In schools, teachers preside over a situation in which the classroom is a microcosm of the art-producing, art-displaying, art-consuming processes in the world at large. The societal importance of art education is based on the fact that the microcosmic situation influences the macrocosmic situation.
>
> Politics is generally understood as an ongoing struggle among individuals, parties and factions for *place, power, and influence* at all levels of social interaction. Art education participates in these struggles by calling attention to the political significance of an image when that significance *declares itself*. The *ideological* significance of an image depends on its aesthetic effect, which can be seen as supporting Whig or Tory, Liberal or Conservative, Democratic or Republican, principles. However, aesthetic effects can also be examined in the light of their sexual, social, and theological significance. From a professional standpoint, therefore, decisions about how to explain aesthetic effects should be made on pedagogical grounds such that the meaning of the image takes precedence over the politics of the teacher.
>
> *Influence* is a term of art among scholars of art. Its meaning ranges from the visible effect of instruction on a student's work, to the impact of certain ideas and experiences on an artist's imagination, to the capacity of visual images to change popular attitudes and actions. This last meaning of "influence" relates art to *power*—a relationship that links art education to politics and social responsibility.
>
> In democratic societies, art education *policy* is developed in the light of *public opinion*. Thus, an important political function of art educational *leadership* is the mobilization of public opinion for the purpose of *building support* for programs whose value is known to us but not readily apparent to others. The principal technique of building that support might be called *propaganda artes*, or arts public relations—persuading people that our professional agenda is defined by their perceived needs.
>
> The highest mission of art education leadership is to provide *op-*

portunity and scope for the creativity of teachers. This is accomplished through any combination of the following: (1) *empowerment,* the delegation of authority to act on one's best impulses; (2) *encouragement,* building teacher confidence by reducing fear of failure; (3) *authorization,* minimizing restraints to departures from the conventional wisdom; (4) *applause,* awarding public credit for good results; and (5) *invention,* discovering fresh ways to connect the goals of art instruction with the aims of education and the needs of the community.

The First Amendment *right of free speech* applies to visual art expression, but it is not an absolute right. For example, the display of incendiary student artworks may be restricted in the light of the Holmes "clear and present danger" doctrine, in which "danger" is understood as public expression likely to cause hurt, hate, or violence in the school community. In the democracy of the school, one student's *free expression* cannot be allowed to restrict or cancel the freedom of expression of others—including teachers.

A *democratic* art education is not threatened by the uneven distribution of art ability in a class or school population. The ideals of an open society are compromised only when pupils are denied the *opportunity* to explore the arts and test their talents. If unfair restrictions are placed on the pursuit of art careers, and if the opportunity to see and study great art is limited to social or academic elites, then human resources are wasted, popular taste is cheapened, and the culture's democratic character suffers.

Since the rise of "Pop" art in the 1950s, stylistic distinctions between *popular* and *elite* art have almost disappeared.[11] Today we feel free to draw on all sources and types of visual imagery in our teaching. Still, the *politics* of art education can be muddied by making obsolete distinctions between "high" and "low," or popular and elite art. Those distinctions are essentially ideological; they have diminishing pedagogical significance. With respect to the status of artistic types or genres, our criterion ought to be: the *quality* of an art style, medium, or subject is contingent on the *quality of learning* it promotes.

REFERENCES

BANFIELD, EDWARD C. *The Democratic Muse: Visual Arts and the Public Interest.* New York: Basic Books, 1984.

11 This opinion is confirmed by a sociology professor at the City University of New York as follows: "For vast numbers of Americans, the 'elite' fine arts and popular arts go together: they are not either-or." Judith Huggins Balfe, Letter to the *New York Times,* March 22, 1995.

BERMAN, RONALD. *Culture and Politics.* New York: University Press of America, 1984.

BETHELL, TOM. "The Cultural Tithe," *Harper's,* August 1977.

BOORSTIN, DANIEL. *Democracy and Its Discontents.* New York: Random House, 1974.

BOORSTIN, DANIEL, ARLENE GOLDBARD, FRANK HODSOLL, et al. "Can the Government Promote Creativity—or Only Artists?" *The New York Times,* April 25, 1982.

CASSIRER, ERNST. *An Essay on Man.* Garden City, NY: Doubleday Anchor, 1953.

CHAPMAN, LAURA H. *Instant Art, Instant Culture: The Unspoken Policy for American Schools.* New York: Teachers College Press, 1982.

CHARLTON, LINDA. "Mondale Hits Charge of Politicizing Arts," *The New York Times,* October 17, 1977.

DEMING, W. EDWARDS. *The New Economics of Industry, Education, Government.* Cambridge, MA: Massachusetts Institute of Technology, 1991.

DEWEY, JOHN. *Reconstruction in Philosophy.* New York: Mentor Books, 1950.

EFLAND, ARTHUR. *A History of Art Education.* New York: Teachers College Press, 1990.

EGBERT, DONALD DREW. *Social Radicalism and the Arts, Western Europe.* New York: Knopf, 1970.

ELLUL, JACQUES. *The Political Illusion,* Konrad Kellen (trans.). New York: Knopf, 1967.

FELDMAN, EDMUND B. "Art, Education, and the Consumption of Images," in Elliot Eisner, ed. *The Arts, Human Development and Education.* Berkeley, CA: McCutchan Publishing, 1976.

FELDMAN, EDMUND B. "Ideological Aesthetics," *Liberal Education,* March/April, 1989.

FELDMAN, EDMUND B. "Power in Art Education: Where Does It Come From? Who Are Its Mediators?" *Journal of Aesthetic Education,* vol. 27, no. 3, Fall, 1993.

FINN, CHESTER E. JR. "Teacher Politics," *Commentary,* February 1983.

FRIEDRICH, CARL J. "The Rational Ground of Authority," *Tradition and Authority: Key Concepts in Political Science.* New York: Praeger, 1972.

FROHNMAYER, JOHN. *Leaving Town Alive: Confessions of an Arts Warrior.* Boston: Houghton Mifflin, 1993.

GALLO, ROBERT. *The Poster in History.* New York: MacGraw-Hill, 1974.

GETLEIN, FRANK, and DOROTHY GETLEIN. *The Bite of the Print.* New York: Bramhall, 1962.

HAUSER, ARNOLD. *The Social History of Art,* 2 vols. New York: Knopf, 1951.

HESS, THOMAS B., and ELIZABETH C. BAKER (eds.). *Art and Sexual Politics.* New York: Macmillan, 1972.

HOFFA, HARLAN. "Power Politics and Arts Education," *Arts Education Policy Review.* vol. 94, no. 2, November/December, 1992.

HOLGATE, ALAN. "Political and Moral Overtones of Built Form," *Aesthetics of Built Form.* New York and Melbourne: Oxford University Press, 1992.

HUYGHE, RENÉ. *Larousse Encyclopedia of Prehistoric and Ancient Art.* New York: Prometheus Press, 1957.

KEARNS, MARTHA. *Kathe Kollwitz: Woman and Artist.* New York: Feminist Press, 1976.

KEY, WILSON BRYAN. *Subliminal Seduction.* Englewood Cliffs, NJ: Prentice-Hall, 1973.

LASSWELL, HAROLD DWIGHT. *Power and Personality*. New York: W. W. Norton, 1948.

LIPPMANN, WALTER. "The World Outside and the Pictures in Our Heads," *Public Opinion*. New York: Macmillan, 1922.

LYNES, RUSSELL. *The Tastemakers*. New York: Harper, 1955.

MADEJA, STANLEY S. (ed.). *The Artist in the School: A Report on the Artist-in-Residence Project*. St. Louis: CEMREL, 1970.

McLUHAN, H. MARSHALL. *Understanding Media: The Extensions of Man*. New York: McGraw-Hill, 1964.

McLUHAN, H. MARSHALL. *Laws of Media: The New Science*, Toronto: University of Toronto Press, 1988.

NETZER, D. *The Subsidized Muse: Public Support for the Arts in the United States*. Cambridge, England: Cambridge University Press, 1978.

NISBET, ROBERT. *Twilight of Authority*. New York: Oxford University Press, 1975.

PAPANEK, VICTOR. *Design for Human Scale*. New York: Van Nostrand Reinhold, 1983.

PARET, PETER, and BETH IRWIN LEWIS, *Persuasive Images: Posters of War and Revolution From the Hoover Institution Archives*. Princeton, NJ: Princeton University Press, 1992.

PENNOCK, J. ROLAND, and JOHN W. CHAPMAN (eds.). *Authority Revisited*. New York and London: New York University Press, 1987.

PLEKHANOV, G. V. *Art and Social Life*. London: Lawrence and Wishart, 1953.

POSTMAN, NEIL, and CHARLES WEINGARTNER. *Teaching as a Subversive Activity*. New York: Delacorte Press, 1969.

SHAPIRO, DAVID (ed.). *Social Realism: Art as a Weapon*. New York: Ungar, 1973.

SMITH, VIRGINIA. *The Biography of a Graphic Image*. New York: Van Nostrand, 1993.

SMITH, RALPH A., and RONALD BERMAN. *Public Policy and the Aesthetic Interest*. Urbana, IL: University of Illinois Press, 1992.

SMITH, T. V., and EDUARD C. LINDEMAN. *The Democratic Way of Life*. New York: Mentor Books, 1951.

STAPLES, BRENT. "The Politics of Gangster Rap," *The New York Times*, July 27, 1993.

STONE, WILLIAM F., and PAUL E. SCHAFFNER. *The Psychology of Politics*, 2nd ed. New York: Springer-Verlag, 1988.

STRAUSS, LEO, and JOSEPH CROPSEY (eds.). *History of Political Philosophy*, 3rd ed. Chicago and London: University of Chicago Press, 1987.

VINCENT, ANDREW, and RAYMOND PLANT. *Philosophy, Politics and Citizenship*. Oxford, England: Basil Blackwell, 1984.

THE
PSYCHOLOGICAL
DIMENSION

INTRODUCTION

Art teachers—like educators in general—often justify themselves on psychological grounds. Consider only the following terms from our professional literature: motivation, giftedness, self-expression, affective learning, right-brain thinking, aesthetic experience, education of the senses, creative personality-type, developmental stage theory, sublimation through art, art therapy, exceptional-child education, and quality-of-life education. Even the traditional goals of art education—the identification of talented individuals, training in hand-eye coordination, and the practical application of design principles—have a large psychological component. It seems that the growth of the profession has been accompanied by the growth of its dependence on psychological science.

No wonder that art education sees itself increasingly as a mental discipline based on psychological laws of learning and an abundance of research into the nature of perception, cognition, and creativity. Nor have we been loath to make psychiatric claims: convinced of the healing power of art, some of us hang out our shingles as clinicians; others promote the benefits of drawing or modeling for normal brain development, or, more modestly, for

68

the maintenance of good mental hygiene. All of us sense that art makes its way in education because of its special relation to the human psyche.

A quasi-therapeutic model of art education has been a staple of our profession for more than half a century. Before that, we specialized in the training of good workers and the inculcation of gentle character traits, both of which were supported by a substratum of psychological theory. Here we propose to examine the main parts of that psychological foundation (it would be impossible to examine all of it) in the hope of understanding the mighty superstructures that have been built on it.

SENSATION

Philosophers and psychologists from Dewey to Arnheim assure us that sensing cannot be separated from thinking. They believe there can be no such thing as an "innocent eye." Now consider Cezanne's remark: "Monet is only an eye but, my God, what an eye!" He seemed to be saying that Monet had managed to paint without thinking. I think the truth is quite different: Monet had a very sophisticated eye; when looking at a cathedral or a haystack he was thinking very hard indeed. Monet trained himself *not to see* certain forms, objects, and their associations; he taught himself to see and paint color alone.[1] To be sure, that was a very difficult feat: it involved a coordinated mental and optical discipline; it was hardly innocent or unpremeditated.

Dewey and Bentley[2] maintain that the older philosophers Hobbes and Hume were wrong in believing that sense data are primary units of knowledge which are afterward assembled in the act of thinking. As art educators we concede that seeing and knowing are simultaneous processes, *unless they are deliberately and systematically separated.* That is what Monet did, and that is what we endeavor to do in teaching: we try to make students self-conscious about their seeing. To that end we employ a variety of devices to make students focus on their purely retinal sensations *as opposed to* what they feel, know, or associate with what they see.

It can be argued that there is no such thing as "pure" or "uncontaminated" retinal sensation. After all, the organs of sight are connected to the brain which is connected via the nervous system to every organ and bodily part down to our toes. Presumably every piece of us makes a contribution

1 Monet disclosed his psychological strategy to an American artist in 1889: "When you go out to paint, try to *forget* [my italics] what object you have before you. . . . Merely think, here is a little square of blue, here an oblong of pink . . ." In other words, artistic seeing entails phenomenological thinking, the deliberate suppression of "facts" that present themselves to consciousness during the act of perception.

2 See Sidney Ratner and Jules Altman (eds.). *John Dewey and Arthur F. Bentley: A Philosophical Correspondence.*

to our visual experience. Nevertheless, art education seeks the development of a mode of seeing which attends *first* to visual sensations *and then* to their syntactic and semantic significance. We think this process yields special dividends. As sense data are translated into colors and shapes, organized into forms, and viewed as aesthetic phenomena, they become something more than, *other* than, the "stimulus objects" that caused them originally. That is how art brings new and valuable things into the world.

The differences between objects and our depictions of them testify to the fact that artists deliberately distinguish between what things are and how they look: they manipulate their sensations[3] as well as the forms they create with wood, clay, metal, and paint. Indeed, the organized "manipulation of sensations" would make a good psychological definition of art education. Cézanne spoke often of the "realization of [his] sensations," by which he meant searching for the linear, planar, and chromatic equivalents of his experience in the presence of nature. His artistic achievement resulted from a lifelong struggle to depict *certain* sensory data, mainly the phenomena of color saturation. Previous painters had created form by imitating variations in line, shape, tone, and the contrasts of light and dark. Cézanne broke with that precedent. Our point is that the artistic mode of sensing is not a "normal" or everyday way of having an experience: it is a learned way of attending to sensory phenomena. That mode of attending is undertaken in order to see the world afresh.

So artistic production entails a "different" or "heightened" type of seeing. Does this mean that art students should be "athletes" of the senses? Should art teaching strengthen their lenses, sensitize their rods and cones, enhance their retinal function, speed up their visual scanning? Not at all. We teach students to see color differences, to follow the changing direction of lines, to identify variations in shape, to measure angles and spaces, to calculate size relationships, and to observe the interactions among these things in the hope of discovering something new and interesting. In that sense art educators teach special seeing skills—distinctive modes of attending to sensations—but for the sake of optimizing visual experience.

Optimizing visual experience—seeing intelligently and pleasurably— can be accomplished with ordinary eyesight; the unique contribution of art instruction is the cultivation of a *discipline of seeing* that enhances one's powers of visual discovery and discrimination. That enhancement depends, of course, on the aesthetic organization of what we are looking at. Seeing is an active[4] process that requires effort and intelligence, but it cannot make a silk purse out of a sow's ear: the education of the senses cannot be sepa-

3 The psychological term here is "sensory processing."

4 The "active" character of seeing is described by Friedländer as follows: "Seeing . . . signifies doing something, it connotes spiritual emotional action. The word 'perceive' indicates that we grasp something with the pincers of the sense of sight and take something in." (See Friedländer, Max J. *On Art and Connoisseurship*, p. 19.)

rated from the character of what is seen. In other words, educational quality depends on aesthetic quality. And that calls for good "critical lenses" behind our optical lenses.

PERCEPTION

It is possible to create art without a theory of perception, but one cannot *teach* art without a theory of perception. By "theory" I mean a set of considered ideas about what happens when students see, remember what they see, depict what they see, and understand what they see. As a practical matter, our ideas about perception do not require authorization by scholarly sources; nevertheless, a theory is necessary to inform art instruction. Without the guidance of a theory of perception, art teaching has an improvisatory character which can make our instruction uneven and confusing.

It should be added that teachers of art history, criticism, and aesthetics need a theory of perception as much as teachers of studio subjects. That is because perceptual modes are not given by nature; nor are they fixed forever. Yet we find teachers giving the same lectures about the same artworks to successive generations of students as if their habits of perception had not changed. The laws of optics do not change, and the physiology of perception does not change, but viewers change in the way they "pay attention" to the deliverances of their senses. Although teachers need not be governed by the perceptual habits of students, they ought to know what those habits are, what students notice, and what they ignore—what they *fail* to see.

The art teacher's goal of "educating the senses" is really a metaphor for *perceptual* education. That goal receives support from impressive sources. According to the painter Oskar Kokoschka, "The eye is like a hand. It grasps some things and ignores others. The eye has its own language."[5] The connoisseur Bernard Berenson said: "What we generally call 'seeing' is a utilitarian convention, built up in the race since it has been human and perhaps when still 'higher animal'. . ."[6] The psychologist Wolfgang Kohler says: "We must learn to make the all-important distinction between *sensations* and *perceptions,* between the bare sensory materials as such and the host of other ingredients with which this material has become imbued by processes of learning."[7] And finally, the philosopher Ernst Cassirer says: "The depth of human experience . . . depends on the fact that we are able to vary our modes of seeing, that we can alternate our views of reality."[8] Running through these statements is the conviction that seeing has

5 Quoted by J. P. Hodin in *The Dilemma of Being Modern*, p. 76.
6 See Berenson, Bernard. *Seeing and Knowing*, p. 6.
7 See Kohler, Wolfgang. *Gestalt Psychology*, p. 43.
8 See Cassirer, Ernst. *An Essay on Man*, p. 216.

a history, a history that is learned and is not easily reducible to the sum of our visual sensations. As a teacher, I favor the way Cassirer makes the point: we can "vary our modes of seeing." This would seem to mean that seeing is related to our freedom, that it can be *instructed* and through that instruction carried into the "depth of human experience."

If you have taught a class to draw from the human model, you cannot help seeing that each student's drawing is different even though the students are looking at the same model. You may notice, too, that the drawing differences appear to be based on the student's personality, gender, height, weight, physiognomy, and bodily proportions. Apparently, the drawing act involves more than registering and reproducing retinal impressions; the artist's self-image seems to affect what is "objectively" seen.[9] Many factors (including self-image) affect what happens when we look at an object or a person, consider what we have seen, and proceed to make the pattern of lines, marks, and tones we call a drawing.

The things that "happen" inside a student's head during the act of drawing go under the general heading of artistic perception—a psychological process we have studied for a long time. Through this "action research" art teachers inevitably learn something about the variables affecting human perception. We learn by watching what students make *as* they make it, as they see what their peers are making, and *in response to* our pedagogical intervention. What this research lacks in experimental rigor is made up by the opportunity to observe the results of several simultaneous interactions—between objects and their images, between observers and the observed, and between the art of our students and the culture that surrounds them.[10]

Returning now to an art *teacher's* theory of perception, what should its focus be? With respect to studio performance it should be the processes of seeing-and-thinking manifest in the images students create. Thus, teaching becomes the business of studying perceptual variation by focusing on how students see, and organize what they see, in the course of making an artistic statement. Every line, color, shape, and visual relationship is for us a choice made from an array of technical, thematic, and expressive possibilities available to the student at a particular stage of his or her development. We have a privileged view of the process of perception; perhaps no one else *sees* artistic perception as we do.

With regard to critical and aesthetic perception, teachers are again in

9 William James makes the point with characteristic clarity: "Whilst part of what we perceive comes through our senses from the object before us, another part (and it may be the larger part) always comes out of our own head." (See James, William. *The Principles of Psychology*, II, p. 103.)

10 For a study of some of these themes, see Kenneth Beittel, *Mind and Context in the Art of Drawing*.

a privileged position. We see, hear, and witness the *construction* of our students' perceptual habits on the basis of their visual impressions, prior knowledge, spontaneous feelings, and tentative judgments. We watch as students *negotiate* with works of art, trying to decide what and how much of themselves they are willing to invest in an image. These are psychological decisions in which we act as advisors; *our* teaching is the business of guiding *their* expenditure of aesthetic capital. Thus, we operate at the very heart of perception—sharing our visual enthusiasms and trying not to indoctrinate. It is a very delicate, and creative, sort of work.

IMITATION

We cannot overestimate the importance of imitation when inquiring into the psychology of art teaching. In Plato's aesthetics, imitation or *mimesis* is crucial: he sees it as the art of the poet, the painter, the sculptor, and the actor. As for teaching art, we need only consider the role of *mimesis* in drawing, modeling, copying, and abstracting from reality. Mimesis plays a comparable role in kinaesthetic response, symbol creation, and the adaptation or modification of art styles. Especially important for art instruction is the fact that imitation is implicit in our most commonly used teaching method: demonstrating techniques and creative strategies.

Insofar as art history is concerned, it *begins* with imitation and impersonation. A great prehistorian, the Abbé Breuil, has said: "Every being tends to harmonize with its background by an unconscious mimetic urge."[11] He says further that "children have an extraordinary propensity for mimicry" and that "the instinct of children and primitive peoples which drives them to imitate the walks and cries of various animals corresponds to the *imitative phase* [my italics] of art . . ."[12] All of which suggests that the imitation principle operates not only in the beginnings of art but also in the phylogeny and ontogeny of our species.

Curiously, imitation has a connotation of thievery. When we imitate someone's behavior, we engage in a kind of stealing: we try to acquire through mimicry something that *belongs to* another person. Similarly, when we imitate the appearance of a person—when we make his or her likeness—we try to gain possession or control over that person. That is how the artistic act becomes a psychological fact. What makes that act psychologically potent? Resemblance. In this respect children think like the earliest human beings: both believe they gain power over creatures and things through their ability to make *convincing images* of those creatures and things.

11 See Breuil, Abbé Henri. "The Paleolithic Age," in René Huyghe (ed.). *Larousse Encyclopedia of Prehistoric and Ancient Art,* p. 30.

12 Breuil, *ibid.*

Implicit in the mimetic principle that resemblance equals power is another principle: the creature (or thing) and its image are identical. That is, a convincing imitation is as real and vital as its original: the model and its image are in essence the same.[13] Hence anything we do to or with a duplicate image is done to or with its original. The duplicate image becomes a genuine substitute or "stand-in" for the original. If we pour water on the head of the stand-in, the original will get drenched.

Once the magical effectiveness of imitation has been established as a psychological and religious principle, it follows that the *imitator*—the artist—wields real power in the world. Using that power, the artist can endow visual forms with life even if the forms do not precisely resemble their real-life model. The principle of symbolic abstraction is established: the power of physical resemblance is weakened and the power of visual *signs* is enhanced when society declares that a particular configuration of marks *stands for* a certain creature or thing.

As visual forms are conventionalized in art, as abstraction replaces naturalism, the magical power of the artist begins to fade. This development, which took place historically during the transition from the Paleolithic to the Neolithic era, corresponds in the lives and art of children to the diminution of their iconic power and the growth of their verbal fluency and reasoning powers. In Lowenfeld's terminology, the child artist leaves the stage of "dawning realism" and enters the "pseudorealistic stage" which, according to Lowenfeld, is a preparation for the "crisis of adolescence."[14]

"Crisis" seems to be the right word for a stage of psychological development in which the mimetic powers of most individuals go into decline. For art education it is also a crisis: the pupil's spontaneous flow of imagery ceases, to be replaced by hesitant and often cramped artistic production accompanied by what seems to be a painful and excessive self-criticism.

The mimetic impulse goes underground, so to speak, and art teachers are faced with a professional dilemma: Should they invent ever more ingenious devices for restoring the *feeling*, at least, of the child's copious flow of images? Should teaching take the form of guiding the student's mimetic impulses in the direction of abstract and symbolic image creation? Or, should the mimetic enterprise be abandoned in favor of taking up the systematic study of art history and aesthetics, that is, the study of art created by persons who have survived adolescence with their mimetic powers largely intact?

13 This principle permeated ancient Egyptian civilization. The "reserve heads" of a pharaoh were considered as real (and alive) as his mummified head in its shroud, in its mummy case, in its sarcophagus. Each of these "containers" held a likeness of the king on its surface; that surface image *vitalized* everything within it.

14 See Lowenfeld, Viktor. *Creative and Mental Growth.*

In practice, most art teachers choose a combination of both options. This would appear to be a realistic accommodation to the facts of psychological development and intellectual growth. Beyond expediency, that accommodation represents an acknowledgment of the fact that there are losses as well as gains in the process of growing up.

With reference to the first option, we might offer this observation: it is a *romantic* option, one that good teachers may choose because they remember the wonderful time when it was possible to make and possess whatever our hearts desired. But alas, each of us must leave our garden of innocence; each of us must suffer what seems to be a loss of imaginative vitality. What happens, of course, is that our creative energies are redirected by culture into a new path. Obviously, the task of teaching changes; it becomes the business of showing students that they can travel along a new path without forgetting the garden in which they once lived and rejoiced.

PERCEPTUAL OUTCOMES

As mentioned, art education tries to develop special habits of visual perception. That is why the psychological dimension of art education has cognitive import; it plays a large role in the formation of mental predispositions that we may call "perceptual outcomes." What are those outcomes?

First is the discovery that *seeing is a way of knowing.* This does not mean that seeing *leads to* knowing; nor does it mean that seeing is "superficial knowing." Seeing *is* knowing. Why? Because a percept involves the *organization of sensory events;* because thoughts have the structure of visual images; because thinking is the mental equivalent of manipulating visual forms.[15] Finally, seeing is knowing insofar as the knower and the known "belong to" each other.[16] Viewers and objects are involved in an exchange of each other's energies and properties. Stated somewhat mystically, seeing involves an exchange of substances.

A second perceptual outcome: we learn that *seeing is a way of solving problems.* This discovery applies to the seeing that goes into the production of an artwork, the explanation of an artwork already created, and the business of answering questions that arise in the course of ordinary living.

15 For a full discussion of perception as thinking, see Rudolph Arnheim, *Visual Thinking.*

16 Emerson supports this idea when he says "the act of seeing and the thing seen, the seer and the spectacle, the subject and the object, are one." (See Emerson, Ralph W. "On the Over-Soul" in Brooks Atkinson (ed.). *Complete Essays of Emerson,* p. 262.)

What problems are implicit in this visual mode? The problems of being, purpose, meaning, goodness, and value.

Our third perceptual outcome is a corollary of the second. We learn that it is possible to *visualize processes, relationships, and theoretical conditions* which have not been previously considered or experienced. If we are so inclined, our visualization can be directed toward the clarification of present conflicts and dilemmas. If not, our visualization serves "softer" purposes such as intellectual exercise, fantastic speculation, and aesthetic pleasure. In all these cases, art education promotes a type of metaphorical learning which has the potential for transfer to nonartistic modes of thinking and acting.[17]

A fourth perceptual outcome is *the ability to see visual forms as cognitive products.* From the standpoint of education, this is a pedagogical bargain. The relatively simple and inexpensive technologies of art enable pupils to encounter high-level principles of learning such as abstraction from sense data, the construction of symbols and concepts, selective perception, distortion by affect, and reasoning by analogy. These principles can be seen at work in the art students make and in the art they study. In both cases they are perceptual outcomes, *cognitive* outcomes. I believe they strengthen the claim of art education to be an academic discipline which has its own distinctive modes of inquiry.

MOTIVES AND MOTIVATION

Art teachers are often tempted to reduce motivation to psychological technique. Because we believe images are latent in the human psyche, we see our task as summoning them up by resort to psychological devices such as stimulating memory images, contemplating stains and splatters, reorganizing scribbles, or listening to recorded music and hoping that pictures will pop into our heads. When it comes to devising mental tricks to encourage the production of images, we are exceedingly inventive. After all, art teachers are trained to help students through their creative difficulties; indeed, we need their difficulties in order to use our training. Then, when their problems have been solved, we criticize the results and prescribe future courses of action.

However, our professional edifice collapses if there is no artistic behavior, if there are no creative difficulties, if there are no products to display, analyze, and interpret. So motivation is necessarily the keystone of any art teaching strategy; without that keystone the other stones in our ed-

17 For a discussion of metaphorical learning through art, see Feinstein, Hermine. "How to Read Art for Meaning," *Art Education,* vol. 42, no. 3, 1989.

ucational arch cannot be assembled to form a solid instructional unit. Because so much depends on stimulating (or compelling) students to create images, school art programs become hothouse operations: art motivation becomes the fabrication of artificial environments to make the flowers grow.

Two kinds of motive seem to influence the teaching of art. The first kind might be called *institutional motives;* they grow out of the training of teachers, their employment in schools, and their responsibility for representing the disciplines of art in education. These motives reflect the priorities of nonart teachers, educational psychologists, school administrators, and professors of art. All agree that art making belongs in the curriculum, and that it is the art teacher's task to fit it in. Therefore, to give aesthetic substance to the educational process, to elicit artistic behaviors from pupils, it becomes necessary to translate institutional motives into art teaching practices.

But despite these honorable intentions, institutional motives are not without flaws: they can be actuated by concerns that are at best unrelated, and at worst antithetical, to the character of art as an authentic human activity. Institutional motives, moreover, are vulnerable to the politics of education: the agenda of a dominant discipline such as cognitive psychology, or a clinical movement like client-centered therapy, or an anthropological doctrine like cultural relativism, can overwhelm education, defining the purposes of art instruction and shaping teaching practice. Of course, extra-artistic agendas are not necessarily pernicious, but they can muddy the waters of art as a discipline and divert us from our legitimate purposes. Those "legitimate" purposes grow out of what I call "art-in-the-real-world" motives.

Art-in-the-real-world means two things. First, when using the term "art" we recognize a discipline that has its own agenda—an agenda that exists apart from the uses to which art is often applied in schooling. Most of the world's art has been created for personal, social, and physical reasons that bear little or no resemblance to psychological testing, clinical diagnosis, mental hygiene, or the release of tensions built up in the course of studying academic subjects. One ought to call things by their right names, which means that if we ask children to make art, we should have in mind an activity that resembles art as it is usually understood.

Second, in using the term "real-world" we refer to the genuine needs and interests of students, not of teachers, school officials, test designers, and cognitive scientists. Real-world motives by definition and of necessity have real-life meaning. Indeed, we may say that an artwork—whether created by a kindergartner or a college student—has aesthetic merit and educational value to the extent that it expresses the authentic needs of those who made it. If I am right, the function of art teaching is to discover those

real-world needs and convert them into motives for making art.[18] The same principle applies to instruction in art history and criticism: it is first necessary to ascertain the legitimate needs and interests of students and then to find aesthetic materials that are relevant to those needs and interests.

The foregoing analysis tries to make the following points. First, a narrowly psychological motivation for making art runs the risk of isolating artistic activity from the mainstream of life as pupils live it. Second, institutional motives rather than artistic motives are often the real reasons for the art activity that takes place in school. Third, the agendas of nonart disciplines can become the motives-in-practice of art teachers who have somehow lost touch with the purposes of art-in-the-world. Fourth, art motivation is psychologically sound (as opposed to institutionally convenient) when there is an organic connection between the actual needs of pupils, the legitimate functions of art, and the real intentions of teachers.

Perhaps the best way to summarize my cranky advice about motivation would be as follows. When assigning a problem in art, when asking students to make this or study that, we should ascertain whether our motives can withstand the scrutiny of real people, especially those who have to comply with our requests.

CRITICAL THINKING

Critical thinking falls under the psychological heading, "higher mental processes." These processes entail the following operations and skills: analyzing situations, identifying problems, gathering information, coping with ambiguity, reasoning from evidence, interpreting information, tolerating uncertainty, forming hypotheses, creating meaning, devising explanations, expressing opinions, and defending judgments. In doing art criticism—whether of "famous" artworks or of student work—each of these operations comes into play. Because criticism is a major component of art instruction, it is not surprising to learn that we have been teaching "critical thinking" skills for a long time.[19]

It should be stressed that critical thinking skills cannot be taught in a vacuum. To engage in the mental operations, to acquire the cognitive skills, and to realize their psychological benefits, teachers and students must perform critical acts: they must *do* art criticism. The same is true of science: to learn scientific methods we must conduct real experiments in physics,

18 See my discussion of having a "good reason" to make art in *Becoming Human Through Art*, p. 175.

19 For more on this topic, see my *Practical Art Criticism*.

chemistry, biology, and so on. In other words, we have to *do* science as well as read about its findings.

The notion that there is a "key" to critical thinking, a key one acquires by learning a formula but without performing the act of criticism, is mistaken. Just as every work of art is unique, every instance of criticism is unique. For example, we cannot criticize all Impressionist paintings at once; we have to criticize Monet's *Cathedral at Rouen*, Cassatt's *Mother and Child*, and Renoir's *Moulin de la Galette* individually and separately. Afterwards, perhaps, we can generalize about Impressionist technique and subject matter. We have a critical method, to be sure, but that method is employed differently in each case. The lesson here is that we cannot learn to swim on a sofa; we have to get into the water. Sound critical technique helps, but without applying it to specific works of art, we cannot claim to "know" the work.

At this point a curricular question arises: Can one learn critical thinking skills through subjects other than art? Of course. Courses in literature, music, and drama, come immediately to mind. However, art yields *special* dividends that the other subjects cannot supply. The reverse is also true, although the situation is changing. Through no particular virtue of our own, the core of art education—visual imagery—has become an exceedingly prominent feature of modern politics, commerce, entertainment, and education. It is the *image* of a politician or a product that accounts for his, her, or its acceptance. The same can be said of ideas: they are promoted and sold as images and they are psychologically inseparable from images.

The prominence of the visual in our culture coincides with the increasingly iconic character of communication, and this coincidence is responsible for the learning dividends yielded by art criticism. One dividend is "visual literacy," the ability to read images no matter how they are made, notwithstanding their intent, and regardless of their commercial value. Here teachers should remember that the "iconicity" of an image designates its content as well as its form. Indeed, visual form properly understood *is* content. That is why art criticism—the search for meaning in art—is the royal road to the attainment of visual literacy.

It should not be necessary to make a case for visual literacy; we live in a world whose technology has made information and communication a matter of image transmission and image processing. Of course, art criticism is concerned with more than information processing: it represents our best way of gaining access to the *meaning* of the visual stimuli that assault us from every direction. Unfortunately, this approach to literacy is treated rather superficially in schooling.

With respect to our visual literacy deficit, art educators deserve some of the blame: they are not especially aware of the *cognitive value* of the subject they teach. Or they assume that art students will eventually learn to

read images for information and meaning as well as excitement and plea-
sure. Here the lesson of the psychologist Edward L. Thorndike is relevant:
"transfer of training" occurs mainly when we *teach for* it.[20] If the develop-
ment of drawing and painting skills leads to increased visual intelligence,
that intelligence should not be confined to problems of pictorial design. To
exploit visual intelligence fully, we should apply it to situations—visual in-
formation situations—that extend beyond the traditional concerns of im-
age production. In other words, art students should be taught to consider
the significance of an image *outside* the picture frame and *beyond* the
artist's technical intention. That would be the art educator's best contribu-
tion to visual literacy and critical thinking.

THE CHILD-ART AESTHETIC

The psychology of child art is closely related to its aesthetic value, yet the
art of children has long been considered trivial and out of the aesthetic
mainstream. Just as infants were once regarded as incomplete adults, child
art was seen as an incomplete or flawed version of adult art. The notion
that child art possesses a self-sufficient aesthetic grew out of a fundamental
change in our doctrine of the human person. It dawned on us that person-
hood begins very early: a person is anyone who can interact with the envi-
ronment and shape it according to his or her emerging needs.

Maturity in judgment and behavior is, of course, an important goal of
education, but that goal should not obscure the values generated at *every*
stage of human growth and development. As Maslow puts it, the behavior
of children is a "fact of Being" as well as "fact of Becoming." He maintains
that "Healthy . . . children don't live for the sake of far goals or for the dis-
tant future. . . . They are *living,* not *preparing* to live."[21] We would add
that making art is itself a kind of living.

Our willingness to see aesthetic value in a young person's drawing of
a figure, a house, or a landscape grew out of two rather startling new ideas.
First was the notion that a child's artwork conveys information that is cog-
nitively valid for everyone, not just other children. Second was our realiza-
tion that a child's way of depicting the world testifies to the existence of a
visual grammar or logic which is defensible insofar as it is grounded in real
experience, experience that has undergone mental processing in the course
of giving it form. The fact that this logic fades with the onset of maturity
does not diminish its legitimacy in the work the child creates. Now what is
the character of that logic or, stated differently, what are the main features
of the child-art aesthetic, and what is the reasoning behind them?

20 See Thorndike, Edward L. *Human Learning,* 1931.
21 See Maslow, Abraham H. *Toward a Psychology of Being,* (1968) p. 44.

The first feature can be described by a much overused word, "charm." The charm of child art, like the charm of children in general, is related to its honesty. In their speech most children have not learned to be tactful, to avoid taboo subjects, to tell "little white lies." They say what they think, which we find charming because it is so often "right on target." Similarly, in their art, children have not yet learned to depict "correct" size relationships, to use adult conventions for representing location and direction, or to employ mature, that is, "late Western" devices for creating form, space, and depth illusions. Working within the usual media constraints, children draw what they see, feel, and believe at particular moments in their lives and without making concessions to reigning fashions in art.

The result of the child's candor and "tactlessness" is a peculiarly truthful image; that image portrays the world before it has been filtered through the lenses of history, culture, and common sense. That world—a personal mixture of facts and percepts—is the product of a logic that adults have learned to repress. But it is a logic nevertheless, and not without its redeeming features: it can represent the sensuous impact, the emotional importance, and the cognitive significance of things *at the same time*. No doubt that is what appealed to painters such as Picasso, Miro, Klee, and Dubuffet—artists who had at their disposal all the representational devices from classical antiquity to the one-eyed optic perfected by Daguerre. Inferentially, at least, these masters saw in child art a logic that was preferable to the systems of representation they had received from the museums.

Spontaneity, the second feature of the child-art aesthetic, is perhaps best seen in painting. During a child's early years, painting is a natural rather than a rule-governed activity. Like breathing, it is not done after lengthy consideration; the painting gesture tends to be preserved unchanged, uncorrupted by "second thoughts." Furthermore, the wrist, fingers, and small muscles of the hand are not greatly involved in the artistic act: it is large-muscle action and kinaesthetic emotion that the child's image records. Indeed, when looking at pictures by children we sense almost *complete bodily commitment*.

Complete bodily commitment—surely this is what the "action painters," as Harold Rosenberg called them, wanted so desperately to capture in their art. Except that those painters—beset by career frustrations and personal anxieties—employed large brushing gestures to record their anger, disappointment, and existential despair. child artists, on the other hand, use the big brush and the large gesture to seize the world in the same way they hug a parent or sibling. The artistic gesture is an embrace, an act of love; it signifies complete acceptance of the world and the creatures in it.

A third feature of the child-art aesthetic is joy—joy in an experience felt as utterly good and right. It is a fierce joy such as we feel only rarely in adult life. What is the source of that joy? The sense of triumph. In the act of making the image of a person, place, or thing, the child simultaneously

invents and possesses that person, place, or thing. This is, of course, a god-like act, and it is fraught with theological significance. The act of making and possessing, which is a type of triumph, creates the visual conditions that adult viewers understand as pleasure—rejoicing in the created universe.

That at least is the psychological scenario. But how is the expression of joy recognized as an aesthetic quality? First, there are the signs of freedom and spontaneity mentioned. They represent *libertas,* absence of compulsion or restraint in our own living space. Second is the frontal and frequently symmetrical presentation of persons and objects, which means that the "secret" of those persons and objects—their most characteristic aspect—has been found out; the style of frontality represents the child's way of disclosing the truth.[22] Third is the quality of inevitability in every child's artistic expression: the image persuades us that it is what it must be. There is no possibility that another set of lines and shapes, created by another individual, would serve the same purpose or mean the same thing. With respect to the creatures and objects depicted, the child artist is the absolute authority, or, as suggested, a kind of god. He or she commands the world in which the image lives, which is plainly evident in the boldness of the picture's design and execution. We may go so far as to say that the child-art aesthetic has a *cosmogonic* quality: it echoes the verses in Genesis where God examines his creation and says it is good.[23]

From this analysis is should be apparent that the child-art aesthetic is strongly rooted in magic. And magic, as anthropologists have taught us, possesses its own peculiar logic. Although the logic of magic conflicts with the logic of science, that does not invalidate the child-art aesthetic, which is valid insofar as it resolves genuine problems of perception and representation. Notwithstanding its magical character, child art presents us with a truthful account of the world as it actually existed, for a short period of time, for a particular young person. Child art also offers a special dividend. It gives us a glimpse of the world as our ancestors probably experienced it many millennia ago, which is no small thing from an aesthetic or a scientific standpoint.

PERSONALITY AND TALENT

The folklore of art education associates art ability or "talent" with certain personality types and traits. Usually, the sensitive, introspective type is sus-

22 Friedländer makes this observation in connection with the presumption of a unity between frontality and truth in child art: "We have two eyes, and a child will not reconcile itself to one being visible." Max J. Friedländer, *Op. cit.,* p. 125.

23 See especially Genesis 1:31. "And God saw everything that he had made, and behold, it was very good."

pected. But this folklore, while full of notions, is rarely consistent. So we hear that the artist-type is excitable, passive, irritable, insecure, impulsive, lazy, rebellious, disorganized, neurotic, solitary, oversexed, and modestly intelligent. Clearly, there are contradictions here.

Still, the folklore may be wiser than we think: the array of personality traits associated with the artist-type appears to include everyone. Which suggests that everyone *could be* an artist: if personality is a predictor of art ability, then artistic *potential* is well nigh universal. Naturally, this pleases art educators since it creates the possibility of permanent full-time employment.

Personality-type, however, is not highly correlated with art ability. Compared to the folklore about where talent or "genius" comes from, the art-historical record is a better source of data, especially since it began four centuries ago with Vasari's biographies of artists[24] and has since fostered a small industry devoted to monographs on artists. From that vast literature it is plain that "successful" artists—those represented in the collections of great museums—are very much like the rest of us (although the profession may have more than its share of heavy drinkers and suicides). The factors that emerge more strongly than personality-type as predictors of art ability seem to be: opportunity for study, family tradition, social support, and cultural readiness. It must also be obvious from the historical record that female children—regardless of personality and no matter how predisposed to art by interest or early display of talent—have rarely become artists. Today, however, women artists are numerous, from which we may conclude that it is not their chromosomes but their opportunities which have changed.

Because success in art is correlated with so many psychological types, the predictive value of a personality theory of art would appear to be nil. This conclusion is certainly counterintuitive: most people (including many art teachers) think they can recognize art potential on the basis of one or more of the traits mentioned. Their rightness or wrongness, I believe, is a matter of luck. Why? Because the history of modern art has played a trick on theories of artistic ability and creativity theory in general. One suspects that the *artworld* is the culprit: whenever a consensus develops about what art is, who might become an artist, how artists develop, and who deserves to be called a great artist, the artworld proceeds to find important exceptions to the rule. In other words, the artworld (with the considerable assistance of art education) contrives to discover and cultivate artistic ability where it was not thought to exist.

Why is the artworld so contrary? Why does it delight in contradicting the conventional wisdom, the predictions of psychologists, the expectations of teachers, and the judgments of art critics? I think the artworld is

24 See Vasari, Giorgio. *Lives of the Most Eminent Painters, Sculptors, and Architects*, 1550.

perverse because its heart has belonged to the counterculture for at least two centuries. In other words, the artworld has "bought into" the one psychological theory that cancels all the others, namely that art is an act of rebellion against all establishments. From this it follows that whatever we say about art or artists is destined to be contradicted. That contradiction, in turn, is soon erected into a new orthodoxy.

"OUTSIDER" ART

While it has always existed, the art of outsiders[25]—the art of mad, fanatical, handicapped, primitive, naive, and emotionally disturbed persons[26]—began to be studied seriously only in the twentieth century. This is surprising considering that the first artists—shamans, wizards, and visionaries—were psychological outsiders. Somehow, the earliest human groups contrived to exploit the imaginative powers of individuals who would normally have been abandoned, banished, or even killed. Civilized societies, however, struggling always to control the irruptions of unreason in their midst, were late to see the social and aesthetic values that might emerge from unexpected sources. Only recently have we begun to realize that exotic, troubled, and marginal persons have something to say, not only about themselves but about the rest of us.

What is the significance of "outsider" art for artists and, especially, art educators? Of major importance is its departure from conventional aesthetic norms, which suggests that outsider art is an important source of fresh ways to see the world. Second is the fact that this art almost perfectly exemplifies "free expression" since outsiders are usually indifferent to the opinions of art authorities. Third, the physical and psychological isolation of mental patients—often for years—means that their imagery has not been inhibited by societal pressures and constraints. This raises the possibility that psychotic art provides access to forms of mental life that are lost or suppressed in the course of normal socialization and acculturation.

Of special interest to educators in a time of unprecedented social disorganization is the frequently *violent* character of schizophrenic and pathological art. This intrigues us because we know that the creative process necessarily includes destruction. Abstraction, for example, involves suppression and dismemberment; stylization entails squeezing, stretching, and twisting; and composition or design entails everything from displacement to complete annihilation. In other words, the creative process for sane persons and so-called "lunatics" exhibits many of the same characteristics.

25 The term "outsider" is borrowed from a valuable book by Roger Cardinal. (See Cardinal, Roger. *Outsider Art.*)

26 These labels are subjective and stigmatizing, deliberately; that is part of the problem we are studying.

Apart from this sameness in the creative process, there are similarities in the imagery of "sane" and "insane" artists. That sheds some light on the well-known opinion that artists are slightly mad, or that irrationality is a precondition of creativity, or that genius, depression, and personal disorganization are closely linked.[27] Some artists, of course, have good reason to be depressed: they can't find work, or no one will buy their paintings, which leads them to conclude that no one loves them. This could explain the unhappiness, if not the clinical depression and profound alienation many artists feel.

Of course, nonartists can also be depressed. Which means that unhappy people do not always or inevitably create art. Sad circumstances cause some persons to reflect on the sources of their troubles, sometimes stimulating the production of internal images which can be presented to the public in a manner that connects with *their* experience. Yet we get a different story from Dürer. His great engraving, *Melancolia I,* suggests that sadness and endless reflection *paralyze* creativity. Apparently, being an artist requires more than sadness, madness, or profound despair: one needs an effective creative strategy. Having a "creative strategy" means more than learning a mental formula or waiting for flashes of insight: it requires technique and regular habits of work. These are best learned from a good teacher. It is reported that Rembrandt told students who were "blocked" or slow to start: "Take the brush in hand and begin!"

Perhaps certain inferences can be drawn, cautiously, from these ruminations about outsider art. Dejection and neurosis are not the sole causes of artistic creativity; they are at most *proximate* causes. The situation is probably different for individuals suffering from serious mental illness; they are not as likely to be affected by the self-censorship that afflicts most "sane" artists at some point in their careers. In the case of deeply disturbed, especially manic, individuals, the absence of inhibition actually promotes the flow of images. That may explain why some artists try to simulate "madness."[28]

Another explanation of outsider creativity is that naive and primitive artists live in close contact with their imaginations, hence their minds are not overloaded with civilized abstractions and paralyzing cultural constraints. It is possible for an artist to be overtrained, like an athlete who has

27 According to a Harvard psychiatrist, Joseph J. Schildkraut, "Miró suffered from depressive disorders and he often referred to them during interviews . . ." Dr. Schildkraut goes on to cite Roland Penrose as follows: "Behind the cheerful, innocent, even tranquil look . . . Miró has never been immune to attacks of violent anguish and depression." Letter to the *New York Times,* October 24, 1993.

28 In this connection, many artists have tried to suppress their inhibitions with alcohol or other substances. Hashish, for example, was popular among nineteenth century French writers such as Beaudelaire. Unfortunately, lowered inhibition also produces deteriorated artistic and aesthetic judgment.

"peaked" too early. Also, we know that there are artists who are better at practicing than producing.

A third possibility is that in the organic mental disorders—those involving brain malfunction—individuals revert to early stages of human evolutionary development. The images created by such persons might be based on primordial impressions preserved in the so-called "collective unconscious." Hence, their art is not necessarily defective; it merely reflects archaic ways of seeing. Perhaps this imagery was once important from the standpoint of survival. In the case of brain-damaged individuals, they may see the world through cracked lenses, but it is also possible that their art permits us to witness the thinking of creatures somewhat like ourselves, who lived before the dawn of history.

Given these speculations, it should be pointed out that our interest in "outsider" art is not based on morbid curiosity. Nor does it imply a wish to diagnose and treat the "exceptional" individuals who create this kind of art. The art educator is not primarily a therapist, although some of our colleagues use their skills to function in that necessary role.

Mainly, however, we care about the meaning of "outsider" art for "insiders," that is, for the presumably healthy persons who populate our classes. Here the clinical experience for Freud, Jung, and depth psychologists in general is relevant; it suggests that the behavior of psychotics, neurotics, and so-called "normals" differs in degree but not in kind. In other words, every human being occupies a point on a single behavioral continuum. For some of us, that point is not especially fixed, which makes for an "interesting" artistic scene.

CREATIVITY

We should have no illusions in art education that creativity is our private preserve. If "creative" means something like "original" or "inventive," then other disciplines and professions have valid claims to the word. On the other hand, if "creative" refers to the frames of mind that lead to the unique type of production called "art," then we have special knowledge of the subject. Artistic activity has a highly visible character, and since we preside over that activity, we have an "inside" view of the creative process and its products.

When it comes to definitions of creativity there is an inevitable conflict between educators and psychologists. For art teachers, creativity is largely manifest in the technique, expressiveness, and quality of a work of art. For psychologists, creativity tends to be an aspect of personality, a cluster of mental traits such as awareness of problems, flexibility, spontaneity, tolerance of ambiguity, and so on. These traits, we are told, are more or less correlated with intelligence. As for works of art themselves, they may be

signs of creativity but the concept itself is the primary focus of psychological attention.

It should be pointed out, as theologians remind us, that "creation," "creative," and "creativity" began as religious terms. For some theologians the meaning of these terms is confined to the original forming activity of a divine creator; for others the words refer to the ongoing action of God in the world. For psychologists (the theologians of a secular age?) creativity can apply to any productive work—a view which does not preclude the others, while leaving open the possibility that all of us have a share in the world's continuous renewal. The interesting point, I think, is that many people see creativity in a quasi-divine light.

A great theologian, Martin Buber, speaks of creativity as an "autonomous . . . instinct of origination." For him the proper role of teaching is to guide that instinct into "sharing in an undertaking and . . . entering into mutuality." This reference to sharing and mutuality strikes a social note which modern psychologies of creativity—understandably focused on individual traits of personality—tend to overlook. The omission is crucial because, as Buber says, an exclusive emphasis on the originative instinct has the potential for creating "a new human solitariness," whereas he is concerned with "the instinct for communion" which "teaches us the saying of *Thou*."[29]

Buber's "Thou" is a fundamentally religious concept that is actualized when the instinct of origination encounters a loving, answering force. "Only if someone grasps his [the artist's] hand not as a 'creator' but as a fellow creature lost in the world, to be his comrade . . . beyond the arts, does he have an awareness and a share of mutuality."[30] The mere "release" of the originative instinct is little more than an expression of "libido" or "will to power." And here there is a world of pedagogical wisdom: Buber does not want us to lose sight of the communal context of all forms of human production. What creativity requires for its authentic completion and fulfillment is the sense of a "community of work with other(s)."

The religious thought of Reinhold Niebuhr relates creativity to the radical character of human freedom.[31] That freedom gives us the option of directing our powers into both destructive and constructive channels. By virtue of our creation in the image of God we possess immense resources for constructively shaping ourselves, our institutions, and our history. Accordingly, says Niebuhr, "There is . . . no cultural or scientific task . . . in which men do not face new possibilities of the good and the obligation to

29 Martin Buber in an address to the Third International Educational Conference, Heidelberg, 1925. (See Buber, Martin. "The Development of the Creative Powers of the Child," *Between Man and Man*, pp. 85–88.

30 *Op. cit.*, p. 87.

31 Niebuhr, Reinhold. *Nature and Destiny of Man*.

realize them."[32] But we are also tempted to believe our resources are un-limited and that our goals are invariably noble and generous. These self-de-ceptions lie at the heart of the Niebuhrian analysis of personal sin and collective responsibility for evil.

Niebuhr offers a sobering doctrine to art education professionals. He obliges us to confront the fact that cultivating our students' creative power carries an immense responsibility. First because that power is fraught with tragic possibilities, and second because it often leads to overestimations of our capacity to change the world and perfect ourselves. Even so, we cannot avoid our responsibility: Niebuhr argues that the gift of freedom *forces* us to be creators as well as creatures. We are "condemned" to play a role in the unfolding dramas of culture and history; that role represents a tempta-tion to overreach ourselves, but it is also a glorious opportunity.

The theologian Paul Tillich sees creativity as *existential courage.* He traces that courage to the Renaissance worldview according to which hu-man beings—and especially visual artists—first realized that they could ac-tualize their inexhaustible potentialities. For religious existentialists, those "inexhaustible potentialities" comes from God; for secular existentialists they arise from the anxiety we feel when confronting our mortality, the possibility of our nonbeing in a world of nonmeaning. In both cases, cre-ativity is crucial for the ontology of the human person. That is, to become human we must develop the courage of self-affirmation. Like Niebuhr, Tillich argues that we make ourselves truly human through "self affirma-tion," by employing the productive powers bestowed by God or given us by nature and our situation in the world.

Tillich calls self-affirmation "the courage to be."[33] That courage needs to be sustained in the face of the many doctrines according to which our freedom and creativity are essentially meaningless. He maintains that the doctrines which celebrate anxiety and despair are usually the products of a surrender to nihilism. That surrender leads to an acceptance of the emptiness of art and the worthlessness of human existence.

In opposition to the dismal possibilities so often extolled in our cul-ture, Tillich offers his "creative existentialist" affirmation, the courage to make of oneself what one wants to be."[34] That courage, in Tillich's view, is visible in art, which represents our effort to become part of "the creative process of nature and history."[35] Hence human creativity is really a deter-mination to affirm ourselves and our lives "in spite of" our anxiety and de-spair, and in the face of the certainty of our death.

Apart from its spiritual connotations, Tillich's idea of creativity

32 Niebuhr, *Op. cit.,* vol. II, p. 207.
33 See Tillich, Paul. *The Courage to Be.*
34 *Ibid,* p. 150.
35 *Ibid,* p. 106.

would appear to have psychotherapeutic overtones. Which is a welcome bonus! As teachers of art we hope the creative attitude will yield artistic dividends. But even if it doesn't, it might make us more interesting to live with.

THE THERAPEUTIC IDEA

Most of us know the Greek myth in which a sculptor, Pygmalion, solves his deepest personal problems by carving an ivory figure of his love-ideal after the goddess Aphrodite has turned him down. Then Aphrodite takes pity on Pygmalion and brings his figure to life in the form of a real woman, Galatea. Pygmalion marries Galatea, fathers two sons, and founds a great dynasty. This happy ending, of course, has had enormous appeal, from the Greeks to Freud to George Bernard Shaw to the millions who loved Rex Harrison in "My Fair Lady." In addition, the Pygmalion myth seems to epitomize the magic and mystery of art.

Beyond demonstrating art's compelling power, the story of Pygmalion describes art's *therapeutic* function: the artist confronts what we would call his existential *angst*; he fashions an image of what he desires most—what the love goddess has withheld. And because his carved figure is beautiful and persuasive, Aphrodite cannot resist: she grants the sculptor his fondest wish. Thus art overcomes despair, and imagination prevails over reality.

The therapeutic idea holds out the hope that art can make us whole and well. Of course, every task completed and every problem solved makes us feel better. The question is whether "better" is predicated on a prior condition of unwellness or sickness. In the case of a humble Greek artisan, it is plain that the prospect of life without a wife, without love, and without children is profoundly depressing. It also appears that Pygmalion's falling in love with Aphrodite was very neurotic: a goddess could not accept a mere artisan as a lover. Did art solve Pygmalion's problem? Freud seems to think so. By *sublimating* his neurotic symptoms in the form of art, Pygmalion gained fame, riches, and the love of a woman; as he received these rewards he was freed of symptoms. According to Freud, the artist-type continues to be a neurotic personality, but a *perfected* neurotic. So, to answer the question posed above, art therapy *is* predicated on a prior condition of illness; indeed, it was illness that forced Pygmalion to act creatively.

Notice that Freud gives us a masculine model of artistic creativity, although it can be converted to a feminine model by changing the gender labels. Still, Freudians would argue that female creativity operates on different psychodynamic grounds. Because women can have babies, creativity plays a different role in their psychic economy. Men cannot bear children, hence they face the problem of nonbeing from a more depressing

angle of vision. Still, many women do not bear children, and many mothers paint good pictures. Perhaps it is enough to say that the therapeutic idea sees creativity—in men *or* women—as a transfer of psychic energy from neurotic symptom-formation to the production of a commodity—art which society holds in high regard.

Of course, the therapeutic idea of art requires implementation. In therapeutic practice, the aesthetic quality of a patient's art work is considered less important than the psychological benefits of the art-making process. This is especially true of patients suffering from organic disorders.[36] However, for nontherapists—ordinary art teachers—high quality of product is a major focus of the creative process. In the normal course of teaching, this process/product antinomy is rarely resolved cleanly. Still, one may ask whether an artistic project undertaken for nonart or even antiart purposes is not somehow tainted. Does art therapy amount to the use of art materials for compassionate rather than aesthetic purposes?

Philosophically, we would prefer to sail under true colors. Is it right to deceive a patient, or student, in the interest of helping the patient or student? Physicians, we know, often confront the problem of telling a patient all, some, or none of the truth about an illness. Usually they deal with the problem on an *ad hoc*, pragmatic, or expedient basis: What is most likely to serve the patient's best interests? But notice that "best interest" is decided by the physician on the ground that the patient's judgment is impaired by illness. The teaching situation is somewhat different.

In the case of art instruction we are not dealing with patients. Or are we? As mentioned, the therapeutic model of art education assumes each pupil is, in some sense, unwell. We arrive, then, at the theory of art and human nature which informs the therapeutic idea: all of us are flawed in some way, in some degree; none of us is free from neurosis; neurosis (and other psychological maladies) represents creative energy that has been misdirected; human culture exists to give positive direction to our creative energies; art is the cultural activity that converts our shortcomings into something society prizes. As for education, it has the same purpose as art—to make something valuable out of the imperfect stuff we were born with and the unhappy habits we acquired along the way.

CONCLUSION

The following definitional statements together with some additional observations summarize the main topics discussed in this chapter.

We use *sensation* and *perception* interchangeably because modern

36 See Kramer, Edith. "Art Therapy and Art Education: Overlapping Functions," *Art Education.*

psychology has persuaded us to see them as dual aspects of the same thing: *cognition*. Nevertheless, art education has a vested interest in the separateness of sensation and perception—especially in the conduct of instruction. Perhaps it is a matter of realizing that seeing and perceiving involve *different kinds of knowing*. The situation may be analogous to the difference between affective learning and cognitive learning: they cannot be completely separated; each partakes of the other. For art teachers, sensations exist independently even though they participate in the general process of perception.

Every work of art is in a sense *self-expression*, and self-expression is almost *communication*. Communication implies *dialogue*, which requires an exchange of information accompanied by *understanding* or *comprehension*. Because art conveys information about itself and the circumstances of its making, viewers must be able to *read* or *decode* it. Skill in reading or decoding visual signs and symbols is called *visual literacy*. The type of visual literacy which is directed toward enjoying and prizing works of art is called *aesthetic literacy*. The development of aesthetic literacy requires skill and experience in *art criticism*. One of our major missions is the development of many types of visual literacy. Like language education, which calls for learning to read and write words, art education requires the making and criticizing of images.

Personality-type, like creativity theory, has at best a tenuous connection to the character of an individual's artistic performance. Perhaps this is because the artist *as a psychological-type* has mastered various techniques of self-disguise. According to Freud's theory of sublimation, the creative process involves a certain amount of deception and masking. Consider, too, that before 1914, Lowenfeld's haptic personality-type would have been considered highly inartistic. Since World War I, however, haptic nor nonvisual personalities have dominated the art scene. As art critics we are often tempted to draw inferences about the personalities of artists—Leonardo, Van Gogh, or Cézanne, for example—on the basis of their styles. But the art of these painters may lie in their ability to conceal themselves in their work. Which is to say that artists are devious and clever persons, which is another psychological generalization.

The identification of talent, or *art ability,* is a well-recognized mission of art education. But whether that ability is innate, a random occurrence, or a product of training, remains an open question. Today's art educators are reasonably confident that art *skills* can be taught. Traditional tests of art ability involved demonstrations of technical skill as a condition of art academy admission. Before the age of art academies, considerations of class, gender, and family tradition played major roles in deciding who would receive serious art instruction. As for modern tests of art ability, they have not proved very reliable. In any case, reliable tests would be philosophically irrelevant; we believe art instruction should be universally avail-

able. In a democratic society, every child should be "tested" by good art instruction.

Creativity is a theological as well as a psychological category, hence it has large *moral* implications. For art educators it is important to realize that *making art* and *responding to art* are both creative activities, although they are not psychologically identical. In educational research, creativity tends to be identified after the fact, that is, after judgments of originality, sensitivity, ingenuity, and so on have already been made. This confirms the opinion of art teachers that creativity is best known by its fruits: good art does not care who has made it. Indeed, we often encounter originality and ingenuity in the work of students not otherwise considered "creative." The evidence of art history suggests that creativity is an open concept: famous artists do not conform to a single personality type. Hence, making educational policy on the basis of creativity tests would not appear to be very wise.

The *therapeutic idea* in art is founded on two basic premises. The first premise, derived from Freud's theory of *sublimation,* assumes that the artist is a neurotic person who is *motivated* by shame, guilt, or fear to convert his or her neuroses into a socially acceptable form. *Creativity* is the process of *disguising* the artist's neurotic symptoms by employing technical skills and psychological stratagems such as *projection, condensation, displacement, and reversal.* The second premise of the therapeutic idea is that the human mind is a treasure house of feelings and ideas which are blocked by illness from achieving full expression. Thus, the function of teaching is to remove or overcome the restraints to a student's creativity. Creativity is part of the natural (and healthy) condition of our species.

The art of children has an obvious connection to the work of teachers in schools. Less obvious is the presence of a *child-art aesthetic* in everyone's life. That aesthetic has meaning for each of us, whether we become artists or not. Moreover, the child-art aesthetic appears to have a universal character: racial, economic, and cultural differences cannot obscure the psychoaesthetic similarities in the art of children throughout the world. Which is a source of hope to workers in education: those artistic similarities testify to our common humanity and the possibility of building genuinely human communities on the basis of a strong and enduring foundation.

REFERENCES

ARNHEIM, RUDOLPH. *Art and Visual Perception.* Berkely: University of California Press, 1954.

ARNHEIM, RUDOLPH. *Visual Thinking.* Berkely: University of California Press, 1980.

ARNHEIM, RUDOLPH. *New Essays on the Psychology of Art.* Berkeley: University of California Press, 1986.

BEITTEL, KENNETH. *Mind and Context in the Art of Drawing.* New York: Holt, Rinehart and Winston, 1972.

BERENSON, BERNARD. *Seeing and Knowing.* New York: Macmillian, 1953.

BREUIL, ABBÉ HENRI. "The Paleolithic Age," in René Huyghe, ed. *Larousse Encyclopedia of Prehistoric and Ancient Art.* New York: Prometheus Press, 1962.

BRUNER, JEROME S. *The Process of Education.* New York: Random House, 1960.

BUBER, MARTIN. "The Development of the Creative Powers of the Child," *Between Man and Man.* Boston: Beacon Press, 1947.

BUBER, MARTIN. *Between Man and Man.* Boston: Beacon Press, 1955.

BURTON, JUDITH. "Beginnings of Artistic Language," *School Arts,* September 1980.

CARDINAL, ROGER. *Outsider Art.* New York: Praeger Books, 1972.

CASSIRER, ERNST. *An Essay on Man.* New Haven: Yale University Press, 1944.

CLARK, KENNETH. *Moments of Vision.* New York: Harper & Row, 1981.

COLES, ROBERT. *The Spiritual Life of Children.* Boston: Houghton Mifflin, 1991.

EISNER, ELLIOT. "What Do Children Learn When They Paint?" *Art Education,* March, 1978.

EMERSON, RALPH W. "On the Over-Soul," in Brooks Atkinson, ed. *Complete Essays of Emerson.* New York: Random House, 1940.

FEINSTEIN, HERMINE. "How to Read Art for Meaning," *Art Education,* vol. 42, no. 3, 1989.

FELDMAN, EDMUND B. *Becoming Human through Art.* Englewood Cliffs, NJ: Prentice-Hall, 1971.

FELDMAN, EDMUND B. "The Teacher as Model Critic," *Journal of Aesthetic Education,* vol. 7, no. 1, January, 1973.

FELDMAN, EDMUND B. "Clay: Arguments For and With," in Gerry Williams, ed. *Studio Potter,* vol. 16, no. 2, 1988.

FELDMAN, EDMUND B. "Formalism and Its Discontents," *Studies in Art Education,* Winter 1992.

FELDMAN, EDMUND B. *Varieties of Visual Experience,* 4th ed. Englewood Cliffs, NJ: Prentice-Hall, 1993.

FELDMAN, EDMUND B. *Practical Art Criticism.* Englewood Cliffs, NJ: Prentice-Hall, 1994.

FREUD, SIGMUND. *A General Introduction to Psychoanalysis.* Joan Riviere (trans.). New York: Garden City Publishing Company, 1943.

FRIEDLÄNDER. MAX J. *On Art and Connoisseurship.* Translated by Tancred Borenius. Boston: Beacon Press, 1942.

GARDNER, HOWARD. "Exploring the Mystery of Creativity," *The New York Times,* March 28, 1979.

GARDNER, HOWARD. *Artful Scribbles: The Significance of Children's Drawings.* New York: Basic Books, 1980.

GEDO, MARY. *Picasso: Art as Autobiography.* Chicago: University of Chicago Press, 1980.

GOLOMB, CLAIRE. *The Child's Creation of a Pictorial World.* Berkeley: University of California Press, 1992.

GOMBRICH, E. H. *The Image and the Eye.* Oxford: Phaidon Press, 1982.

HARRIS, DALE B. *Children's Drawings as Measures of Intellectual Maturity.* New York: Harcourt, Brace & World, 1963.

HODIN, J. P. *The Dilemma of Being Modern.* New York: The Noonday Press, 1959.

HURWITZ, AL, and MICHAEL DAY. *Children and Their Art,* 5th ed. San Diego: Harcourt Brace Jovanovich, 1991.

JAMES, WILLIAM. *The Principles of Psychology,* II. New York: Dover, 1950.

KAGAN, JEROME, ed. *Creativity and Learning.* Boston: Houghton Mifflin, 1967.

KAUFMAN, LLOYD. *Perception.* New York: Oxford University Press, 1979.

KOHLER, WOLFGANG. *Gestalt Psychology.* New York: Mentor Books, 1947.

KRAMER, EDITH. *Art Therapy with Children.* New York: Schocken Books, 1971.

KRAMER, EDITH. "Art Therapy and Art Education: Overlapping Functions," *Art Education.* Reston,VA: National Art Education Association, April, 1980.

LIPPS, THEODOR. "Empathy, Inner Imitation and Sense Feelings," (1903). In Melvin Rader, ed. *A Modern Book of Esthetics,* 3rd ed. New York: Holt, Rinehart & Winston, 1960.

LOWENFELD, VIKTOR. *Creative and Mental Growth.* New York: MacMillan, 1947.

MASLOW, ABRAHAM H. *Toward a Psychology of Being.* New York: Van Nostrand Reinhold, 1982.

MAY, ROLLO. *The Courage to Create.* New York: W. W. Norton, 1975.

MERLEAU-PONTY, MAURICE. *Phenomenology of Perception.* Colin Smith (trans.). New York: The Humanities Press, 1962.

MORGAN, DOUGLAS N. "Psychology and Art: A Summary and Critique," *Journal of Aesthetics and Art Criticism,* vol. IX, no. 2, December 1950.

MUNRO, ELEANOR. *Originals: Women Artists.* New York: Simon and Schuster, 1979.

NIEBUHR, REINHOLD. *Nature and Destiny of Man.* New York: Charles Scribner's Sons, 1951.

PERKINS, DAVID, and BARBARA LEONDAR, eds. *The Arts and Cognition.* Baltimore: The Johns Hopkins University Press, 1977.

PHILLIPS, WILLIAM. *Art and Psychoanalysis.* New York: Criterion Books, 1947.

PIAGET, JEAN. *The Child's Conception of Space.* London: Routledge and Kegan Paul, 1956.

PRINZHORN, HANS. *Artistry of the Mentally Ill.* Heidelberg: Springer-Verlag, 1972.

RATNER, SIDNEY, and JULES ALTMAN, eds., *John Dewey and Arthur F. Bentley: A Philosophical Correspondence.* New Brunswick, NJ: Rutgers University Press, 1964.

READ, HERBERT. *Education Through Art.* New York: Pantheon Books, 1945.

SCHAEFER-SIMMERN, HENRY. *The Unfolding of Artistic Activity.* Berkeley: University of California Press, 1948.

STRAUS, ERWIN. *The Primary World of the Senses: A Vindication of Sensory Experience.* London: Collier-Macmillian, 1963.

TEJERA, VICTORINO. *Art and Human Intelligence.* New York: Appleton-Century-Crofts, 1965.

THORNDIKE, EDWARD L. *Human Learning.* New York & London: The Century Company, 1931.

TILLICH, PAUL. *The Courage to Be.* New Haven, CT: Yale University Press, 1952.

VASARI, GIORGIO. *Lives of the Most Eminent Painters, Sculptors, and Architects,* 1550.

WINNER, ELLEN. *Invented Worlds: The Psychology of the Arts.* Cambridge, MA: Harvard University Press, 1982.

THE COGNITIVE/MORAL DIMENSION

INTRODUCTION

By discussing cognition and morals in the same chapter we raise the classical question: Is there a necessary connection between sound knowledge and right action? The Greeks thought so; that was the main thrust of their philosophy and paideia—*knowing* the good in order to *be* good. The Hebrews, on the other hand, set greater store on *doing* good first and thinking about goodness afterward. In any case, stupidity was not much admired in the wisdom literature of any ancient people. However, the pedagogues of antiquity believed one could *learn* to be good. They also assumed that ethical behavior requires a modicum of intelligence—intelligence mixed with fear. Fear, in turn, was understood as *knowing* what happens to transgressors of the Law or Custom or the Received Wisdom.

In recent times, a necessary connection between knowledge and wisdom, intelligence and goodness, or education and ethics has been seriously questioned—especially by moral philosophers. Schools, however, continue to operate on the assumption that it is better to know than not to know. Ignorance has few supporters among educators, which may explain the extraordinary amount of time and effort spent on studying the mechanisms of

learning. We keep hoping that learning will produce better—morally better—human beings.

Now, art education is often regarded as an *alternative* way of learning, with "alternative" understood as a nonintellectual, if not *anti*-intellectual, path to cognition. However, we cannot afford to be known as a "know-nothing" discipline, that is, a discipline that doesn't know how it knows. We have cognitive claims to make, and they need to be taken seriously. After all, art teachers are employed by institutions dedicated to the dissemination of knowledge. Given that dedication, we should not seek exemption from our intellectual responsibilities—not on the ground that real knowledge is best left to science, or because the senses "know" what the mind will never discover, or because art employs a mode of knowing so subtle as to defy ordinary understanding. Neither should we fulfill our obligations by making an academic caricature of art education—blowing it out of shape with inflated claims, reducing it to arid formulas, or turning it into a desert of facts and statistics. We need to show the public that art teaching is legitimately connected to knowing, and high-quality knowing at that.

As for teaching morals, this scares us because we think religion constitutes the only sanction for moral instruction. Given the "wall of separation" between religion and education in American schooling, we would rather avoid the subject. However, the *problem* cannot be avoided: moral actions and purposes are implicit in the daily life of a school community and, more particularly, in the meanings and methods of our discipline. If art is about life, if it involves constructive or destructive intentions, right or wrong procedures, and good or bad outcomes, then it cannot be taught without considering its moral and ethical[1] implications.

It might be argued that art makes progress *despite* moral strictures and pietistic injunctions. That argument is best left to historians and philosophers of art (who would probably agree that art history records *moral change* more than *moral progress*). In any case, art educators must view the good of mankind from a special angle of vision. Since we are teachers of persons as well as subject matter, we cannot ignore the moral dimensions of our discipline: we have to teach character as well as technique. And teaching character, as Buber said, is the only education "worthy of the name."[2]

When teaching art we encounter students in the fullness of their being, so we cannot be indifferent to the wholeness of their development.

1 Technically, "ethics" is the *translation into action* of a moral code or a set of moral convictions. In practice we use "moral" and "ethical" interchangeably since an ethic implies a morality whether we acknowledge it or not.

2 See Buber, Martin. "The Education of Character" (1939), *Between Man and Man*, p. 104.

Wholeness, we know, is linguistically related to "hale," "health," and "holistic," a roundabout way of saying that the cognitive and moral dimensions of a subject should not be separated from *teaching* that subject. That would be true of any educational philosophy "worthy of the name."

ART AND TRUTH

There is a variant of a saying by Josh Billings[3] which goes as follows: "He knows a lot but a lot of what he knows ain't so." For educators that saying alerts us to obligations beyond pure acts of knowing: we should be concerned with knowing things that are true. Well, does our concern with truth extend to art and art instruction?

Obviously, art teachers want to transmit reliable information about technical matters. Philosophic problems arise mainly when we ask whether artworks are reliable in their aesthetic content, in the truth value of the experiences they generate.

Perhaps this question is best analyzed through recourse to an actual work of art. If I examine Gauguin's canvas, *The Spirit of the Dead Watching,* I feel reasonably sure that the Tahitian girl lying on a bed is a real person and that she is troubled. I am less certain that the old woman at the foot of the bed is real. However, I have no doubt that she has a real existence in the girl's imagination. So the painting exists for me as a mixture of forms, persons, and relationships that were observed or imagined by Gauguin. I build my experience on a foundation constructed by the artist using materials ranging from his direct knowledge of Tahitian society, to his imaginative reconstruction of a Tahitian girl's inner life, to my knowledge of young girls and old women.

The truth value of my experience depends to some extent on Gauguin's *anthropological* reliability. Is the religious situation accurately portrayed? Is the ethnological setting reasonably correct? Is the girl's emotional condition plausible? From what I know, could such an event take place? The truth of the work depends also on purely artistic factors: Does the representation of the girl's body convince me that she is worried by the silhouette at the foot of her bed? Am I persuaded that an encounter between the spirit world and the flesh-and-blood world could occur in the virtual space of this painting? To the extent that I am persuaded—anthropologically, psychologically, and aesthetically persuaded—the picture is truthful. The depiction of the event is valid insofar as this particular observer "buys into" its world.

We may further say that the truth value of Gauguin's *depicted* event is

3 See Billings, Josh. *Encyclopaedia of Wit and Wisdom.*

as solid as a written account of a similar event. Why? Not because the painting makes assertions that can be disputed by others. Nor is it necessary to translate the picture into propositional statements that can be subjected to logical analysis. The Gauguin work is truthful because it organizes our perceptions, feelings, and awareness of ideas and actions such that we are willing to affirm they are valid as we examine the forms, as we reflect on their relationships, and as the image in its totality conforms to our experience of the world and the creatures in it.

What I have just described might be called *representational* truth. Notice that it is not identical to visual fidelity or photographic accuracy. Representational truth makes *aesthetic* assertions about a particular theme or subject matter; those assertions are embodied in visual forms that we sense and perceive in context. That is, their comprehensive meaning is contingent on visual and/or syntactical relationships. Those relationships are subject to verification by me or other observers *as we compare them* to relationships we have experienced in the world we know.

The truth of our experiences in art and the truth of our experiences in life have a common source: perception. Better stated, truth is rooted in the perceptions of particular persons bringing their best resources of knowledge and imagination to bear on particular sets of facts. Explanations of those sets of facts can be confirmed or disconfirmed by other perceivers employing their own criteria of verifiability. We should not deny any person the right to say, with Saul Bellow: "Yes, yes, that's it, that's true. What he [the artist or poet] says is true. I've known it all along, only now it's clear to me because he has said it."[4] In other words, aesthetic confirmation—the assent that comes from the heart—has a place in education because it happens in life; we use it all the time.

KNOW-HOW KNOWLEDGE

Everyone knows that art instruction entails technical experience, which leads to "know-how" knowledge. But because of an ancient prejudice, technical knowledge is considered educationally inferior—certainly nonacademic. If a student acquires technique or "know-how" knowledge, that knowledge is deprecated (except when we need it)—presumably because it involves muscular rather than cerebral effort.[5] This view is based on the antiquated notion of a mind-body split; it also reflects the Crocean theory of art as the intuition of pure ideas.[6] Because ideas are formless, col-

4 See Bellow, Saul. "Love, Art and Identity," *The New York Times.*

5 See Sorri, Mari. "The Body Has Reasons: Tacit Knowing in Thinking and Making."

6 See Croce, Benedetto. *Aesthetic,* pp. 1–26.

orless, and weightless, their existence is independent of material substances; this makes them more durable and presumably more valuable than technical products. Because art is dependent on technique, it is necessarily a fleeting thing; it has lasting value only to the extent that its technical effects are the outward expression of inner ideas.

One can easily recognize the Platonism implicit in this argument; it leads to an interesting educational doctrine: from the standpoint of learning efficiency it is better to study ideas directly, that is, to encounter them in forms which are relatively free of sensory excitation. To the extent that artistic effects are appealing, they *distract* us from recognizing ultimate knowledge. Edman puts it this way: "Plato does not so much think the artist incites the flesh as that he *diverts* and *distracts* [my italics] the mind . . ."[7] For educational purposes, visual form is little better than a snare and a delusion.

Although the notion of art as the intuition of pure ideas is passé among philosophers, it is still influential in education. This is clear when it comes to assessing learning: we would rather test propositional knowledge than "know-how" knowledge. Perhaps that is why the mastery of art skills is denigrated in many school programs and, surprisingly, in certain art circles. The evaluation of technical knowledge is not easy, and in some educational settings it seems exotic. Determining whether a student understands the connections between form, technique, and expression requires artistic experience and critical insight, which makes the evaluative process uncongenial to the pencil-and-paper mind. So we finesse the problem by concluding that technical mastery has no liberal educational value; it yields knowledge but only of a low-order type. But this is a resort to circular reasoning: real knowledge is what can be computer-graded or read on an exam paper. The great principle here is: words count more than the processes they designate.

Ironically, our inability to appreciate the importance of know-how learning is due to an intellectual failure: most educators, trained to read books, do not understand the logic of tools, materials, and processes. And that, of course, is what art education teaches.

PROPOSITIONAL KNOWLEDGE

Propositional or "know-that" knowledge takes the form of statements that can be ascertained by the probative methods of history or science. Thus, I know that Picasso painted the *Guernica* in 1937 to protest the Fascist bombing of a Basque town in Spain. Actually, I know only that reliable art historians vouch for these facts (most of which rely on documentary evi-

7 See Edman, Irwin. pp. 115–116.

dence). Propositional knowledge usually depends on observations and conclusions made by others and accepted by us in the course of our reading or formal instruction. To be sure, those observations and conclusions contribute substantially to our education, but we may well ask whether they contribute to our knowledge "through" art.

The answer is no and yes. "No" if propositional knowledge acquaints us merely with the principal facts and assertions about a work of art. "Yes" if those facts and assertions *lead to* an understanding of the *relations among* the facts, that is, if they are based on a genuine experience of the work. The art educator would prefer that the facts *emerge from* an encounter with the work such that assertions about it are directly confirmed. We might say that propositional knowledge about art is valid only when it has been personally corroborated. To the extent that it is not based on our own experience, it might better be called by Whitehead's expression: "inert knowledge."[8]

Does this mean that knowledge *about* art is inferior to knowledge *through* art? Not at all; a complete art education would embrace both kinds of knowledge. If we have been inspired or deeply affected by art, then it is natural to seek information *about* it. And if art interests us as a factor in social, economic, or cultural affairs, then we want to know its power personally, through its capacity to organize our inner lives and shape the world we live in.

In the first case cited, knowledge leads to experience; in the second case, experience leads to knowledge. In both cases art educators should take Whitehead's point about "inert knowledge," which he regards as the product of "ideas that are merely received into the mind without being utilized, or tested, or thrown into fresh combinations."[9] Whitehead appears to be saying that real knowledge has the power to rearrange our thinking. The other kind is retained until the next test. After graduation, of course, it is forgotten.

KNOW-WHY KNOWLEDGE

We think we know why the Mesopotamians perfected the art of arch construction. Arches are made of bricks and bricks are made of sun-dried mud. Mesopotamia had few trees and very little stone, but it had mud and sun in abundance. So arches were developed to bridge over space because the materials for building beams, posts, and trusses were scarce. Another example: we think we know why royal robes are blue: the sky is blue, kings and emperors were once considered gods, and gods live in the heavens,

8 See Whitehead, Alfred North. *The Aims of Education,* p. 13.
9 Whitehead, *ibid.*

which are usually blue. We speak of royals as "blue-bloods" for the same reason.

These are examples of "know-why" (or inductive) knowledge in which the "why" question inquires into the conditions or processes that caused what we see. Our first example is not merely technological: it advances a theory of material determinism in architecture; it shows how the maxim—"necessity is the mother of invention"—operates in a specific culture. Our second example goes beyond iconography: it illustrates the type of thinking that leads to the invention of myths and symbols. In both cases we see how "know-why" knowledge grows logically out of art-historical and art-critical study. We also see how answers to causal or "why" questions can lead to fresh understandings of physical, psychological, and cultural processes.

Opportunities for "know-why" knowledge are abundant in studio instruction—in mastering pictorial processes, for example. Consider the answers to the following questions: Why do large forms seem closer to the spectator than small forms? Why do diagonal lines look more active than vertical lines? What makes a bright red more exciting than a pale green? Which is softer, an S-curve or a triangle? Why does a small head make a human figure look tall? How do shadows create three-dimensional effects? Is it possible for a large form to be balanced by a small shape?

The answers to these questions are rarely verbalized in studio instruction. Nor do we classify the answers in terms of the scientific concepts they exemplify—optical perspective, light energy physics, mathematical ratios and proportions, cultural association, psychological projection, and so on. Nevertheless we *know* there are causal relations between the use of a certain pictorial device, the feeling or illusion it generates, and the formal body of knowledge that stands behind the device. This learning constitutes "tacit knowledge," as Polanyi[10] describes it, and "know-why" knowledge as art educators understand it.

Whether an art teacher wants "know-why" knowledge to be tacit or explicit depends on his or her personal motives and educational objectives. One can imagine situations where explicit labeling would serve the purposes of pencil-and-paper testing and hence of academic respectability. For more serious purposes, however, the aesthetic effectiveness of an artwork should be good enough evidence that the "know-why" principle is operative in a student's creative effort. A student who has painted a good picture has probably learned "why" as well as "how" the picture turned out right.

10 See Polanyi, Michael. *The Tacit Dimension.*

QUIDDITY KNOWLEDGE

Rarely discussed but often encountered in art is a product of cognition we may call "quiddity knowledge"—knowledge of the way things are, how objects exist in and of themselves.[11] The German word *sachlichkeit*[12] describes the concept well; phenomenologists from Husserl to Heidegger have written about it extensively, if somewhat opaquely. But for those of us who teach art, the whatness of things is disclosed every day in our students' work.

In the history of art, the quiddity or whatness of things often turns up in still-life painting. One thinks of the still-lifes of the young Caravaggio, or of Zurburan, of a water jug by Velazquez, of food and flowers painted by the Dutch "little" masters, of a Persian carpet in a canvas by Vermeer, of the bottles and jars in a Morandi, and of De Chirico's geometric solids, which look as if they have lived forever. These examples, and many others, constitute a skillful continuation of an inquiry that begins in the life and art of every young person. That inquiry raises the following questions: What are things really like? Do apples and peaches, tulips and teapots, exist in the same sense that I exist? Can I know an orange or an apple by looking at it hard and focusing my attention on it *to the exclusion of everything else?* Stated otherwise, can I know the apple by drawing or painting it with utmost honesty? Does the apple become mine, or part of me, when I see it and paint it exactly as it sits before me, naked and motionless, without pretending that it stands for anything but itself? I think many pupils ask these questions silently. The phenomenologists, like the great still-life painters, merely build on the child's sense of wonder. This idea was well expressed by Annie Dilliard: "Establishing that things are here . . . is no mean feat: it is an effort that kept the likes of Kant and Wittgenstein quite occupied.[13]

Still, it might be asked whether searching for the quiddity of things results in "real" knowledge. Here I think we need an extended answer. Morandi's bottles and the seventh-grader's bowl of fruit are *knowledge embodiments*—of bottles in the first case, of fruit in the second case, and of certain spatial, formal, and contextual possibilities in both cases. Does quiddity knowledge change with the circumstances of its discovery? Yes. Does it matter who does the seeing and reporting? Of course. Is quiddity knowledge interesting or valuable to anyone other than its creator? Here we might answer with a question: Does a lunar landscape by Yves Tanguy

11 Speaking about "the truth of art" versus "the generalized periphrasis of analytic diction," Irwin Edman, alludes to "The truth *of* things rather than the truth *about* them . . ." (See Edman, Irwin. *Arts and the Man*, p. 133.)

12 This concept found expression in a German painting style of the 1920s—"*die Neue Sachlichkeit*," or the New Objectivity.

13 See Dilliard, Annie. "Is Art All There Is?" *Harper's*, August, 1980.

make sense—poetic, aesthetic, or astrophysical sense—to anyone but Tanguy? I think it does. Someday, even physicists will understand it.[14] In the meantime, that little piece of knowledge embodied in the cognitive package we call a work of art might well be entertained as a reasonable hypothesis.

KNOWLEDGE-THROUGH ART

Beyond propositional "knowledge-that," we may speak of "knowledge-through" art. Here we lay claim to a mode of understanding based on having an art *experience*. And because that experience is different from other kinds of experience, we insist that art knowledge is unique. Well, what makes it unique?

To begin with the obvious, "knowledge-through" art is unique because art objects are unique. In other words, there is nothing in the world quite like Grant Wood's painting, *American Gothic;* common sense tells us that our experience of that particular work is unlike any other. It does not matter whether we like the picture, whether we know anything about the artist, whether we recognize his models, or whether we *feel* wiser by virtue of having looked at the picture. What matters are the distinctive ideas and insights generated within us as we encounter this one-of-a-kind object.

A second reason for the uniqueness of "knowledge-through" art lies in the fact that every artwork is a singular blend of the real and the imagined: each work embodies the actual and the possible *in the same physical form*. Thus Woods's farmer and wife are simultaneously specific persons, generalized personality types, and convincing illusions made of colored substances resting on a flat surface. The knowledge based on an art experience originates in a real-world thing or event that is accessible through a succession of progressively more abstract codes manifested in physical "stuff." Even realistic art depends on an abstract code: we think it is real because its code is highly efficient. When a work of art communicates effectively, we are almost unaware of its mode of transmitting information. We might say that "knowledge-through" art depends on awareness of the *codes and modes* that generate our experience. Thus, intelligent persons know they have been moved by a work of art; *educated* persons know how and why they are moved.

Third, "knowledge-through" art is different from "knowledge-that" and "knowledge-about" because it works so intimately with the stuff of the

14 At least one physicist understands it: "Most people express great surprise when they are told that theoretical physicists think in pictures, yet in my entire career as a physicist I have met only one or two people who actually think in equations. (They were the people whom I found it hardest to understand and with whom I least enjoyed discussing physics.)" (See Trefil, James, letter to *Smithsonian Magazine*, p. 14.)

self. Art experience generates knowledge *within* the knower as opposed to knowledge on paper or knowledge in a computer memory. Art knowledge requires our contribution—direct perception—which has the effect of organizing the inchoate materials of our lives and giving them form. That form does not equate so much with facts or information as with our awareness of a process: someone has encountered a piece of the world, incorporated it into the stuff of his or her being, and found a way to share that part of his or her being with me.

To illustrate "knowledge-through" art we might consider Goya's *Executions of the Third of May, 1808*. One can, of course, read histories of Napoleon's Spanish invasion for an account of the grisly facts reported in the work. For information concerning what Goya knew about the invasion, we can consult art-historical monographs on his life and work. But to feel the impact and know the meaning of the event, one must *experience* Goya's painting.

This is not to say that "knowledge-through" art is merely affective and hence more moving than other kinds of knowing. Nor do we wish to say that Goya's painting is an accurate reconstruction of the events of May 3, 1808 in the manner of a good television "documentary." Our claim is more sweeping: we maintain that Goya's picture enables us to know what those who witnessed the event felt and remembered. The *deep structure* of the painting carries the Third-of-May events to a level of consciousness that mere reportage or documentation cannot reach.

Now pictorial structure should not be confused with visual recollection—the accumulation and representation of more or less accurate optical details. Our position is that the *deep structure* of Goya's painting *embodies the inner meaning* of the event. To discover that meaning is to know the event authentically, that is, from the standpoint of executioners and victims alike. In perceiving the deep structure of the painting we negotiate with a set of aesthetic facts that correspond visually and symbolically with the murder of the civilians. The aesthetic apprehension of an event equates with *knowing the truth* of the event.

We arrive, then, at a provisional definition of "knowledge-through" art: it is a type of insight based on encountering the *embodied meaning* of a particular object, place, process, or event. This encounter has cognitive and educational significance for two reasons. First, the meaning of the artwork has an objective reference to facts which do not depend on our personal preferences or biases: they can be confirmed by others. Second, the significance of the work does not yield itself freely: it has to be elicited, and that calls for study or intellectual exertion. What we learn is contingent on (1) the information carried in the deep structure of the work; and (2) the quality of effort expended by the learner (guided, one hopes, by a good teacher).

It should be added, finally, that the visual image format makes it

highly compatible with modern modes of disseminating information and—especially important—conveying the *meaning*[15] of that information. Thus, "knowledge-through" art goes beyond acquaintance with facts: it is the product of an active process which we might call *perceptual grasp*—knowing the facts as they relate to each other, as they add up to an image, as that image embodies insight, and as that insight impacts on the knower. It would be difficult to find a better cognitive package.

THE MEANING DIVIDEND

A large part of the school curriculum fails to reach, or does not seek, the level of meaning. Learning the number facts, the names of the continents, the three branches of government, or the difference between mammals and reptiles, means little except with respect to the further learning it makes possible. In artistic creation, however, the humblest effort strives for meaning. As for art criticism—the obverse of artistic creation—it is by definition a search for meaning.[16]

But what do we mean by meaning—in art or any medium of communication and expression? To answer we could use the help of a rigorous logician and tough-minded philosopher; let us take the advice of Hans Reichenbach, who says "cognitive content is a property of the sign system" [for our purposes, a work of art]. He adds; "A sign combination which can . . . be shown to be true or shown to be false is called meaningful." Finally, as we would expect from an empiricist philosopher, Reichenbach declares that "meaning hinges on verifiability."[17] Verifiability, in turn, depends on whether the assertions made in or through a sign system can be confirmed by observation, employed as a prediction of future events, or used to "account for our actions." This last condition—Reichenbach's "functional" requirement of knowledge—is crucial: Reichenbach insists that "those who accept the verifiability criterion of meaning" act so that their behavior is compatible with their words and understanding. This is a severe (but I think well warranted) standard against which to measure the meaning and truth value of any system of signs.

Works of art, in my opinion, meet at least some of the above-mentioned conditions of verifiability. Even a "bad" work of art can be mean-

15 Interestingly, Suzanne Langer prefers to use "import" instead of "meaning" to describe the meaning of meaning-in-art. But his may be a distinction without a difference. I think she defers too much to "the precise senses [of meaning] known to semanticists." Sometimes, semanticists quibble. (See Langer, Suzanne K. *Problems of Art*, p. 127.)

16 For more on this subject, see my discussion of "Seeing Meaning" in *Practical Art Criticism*, pp. 48–50.

17 See Reichenbach, Hans. *The Rise of Scientific Philosophy*, p. 256, et seq.

ingful in Reichenbach's sense because it is capable of being *disconfirmed*; that is, it can be meaningful even if it is wrong in what it says. The important point is that the signs and symbols constituting an artwork make assertions that can be proved or disproved *in our experience*.[18] Thus, an art-critical judgment can be understood as an implicit statement to the following effect: What I have seen in the work makes (or does not make) sense; it does (or does not) square with my experience; I believe (or do not believe) it speaks truly. In the light of what I have seen, done, expect to see, or would like to do, this work of art is meaningful. I am willing to think and act as if it were true, false, or possibly true.

Here I have probably committed the sin of making a truth-claim about an artistic statement! But as mentioned, I believe works of art do in fact make assertions about the way things are, or could be, or shouldn't be. Moreover, it is clear to me that people have always behaved *as if* those assertions were at least provisionally meaningful—meaningful, that is, according to Reichenbach's "functional conception of knowledge."[19]

To speak bluntly, we should know by now that words and mathematical signs are not the only ways to make meaningful assertions. We should also know that art has been in the meaning business for a long time; surely that is the testimony of cultural history. Art educators should be aware of the fact. And they should teach as if they believe it is true.

ART AND MORALS

The connection between art and morals is commonly argued on the ground that we imitate what we see. Especially in the case of children's behavior, the models often come from art (here understood as every kind of visual imagery) and the learning is frequently exhibited in "acting out." This may be less true with respect to the behavior of adults, but we are nevertheless convinced that seeing leads to doing—or at least to liking and wanting. Therefore, it is not surprising that many intelligent persons regard art as a powerful engine of moral instruction.

Some artists believe their work has nothing to do with morals. They insist motives are technical, expressive, or aesthetic. For them, art is not about the humane treatment of animals, the stewardship of the earth, the rightness of war, or the promotion of decent personal and social values. They are convinced that art and morals are categorically separate, and hence cannot be judged by the same criteria.

But from our standpoint—the standpoint of art teachers—the doc-

18 Here "proved" means tested or tried in real life as opposed to demonstration through reason. I have in mind the meaning of *probare*, the Latin source of our words *probe, probable, probate,* and so on.

19 Reichenbach, Hans. *Ibid.,* pp. 252–275.

trine of art's autonomy (*l'art pour l'art*) is a luxury we cannot afford. First, art instruction takes place in social settings (often involving children) which require us to consider the ethical consequences of our teaching practices and the moral implications of the meanings expressed in the art we study or make. Second, we should not confuse an artist's motivation with the objective results of his or her performance. An artist might paint a picture to remember an experience, to attract attention, or to win a prize. But suppose that picture has the effect of desensitizing viewers to mass violence and human brutality: without being culpable in the legal sense, the artist is morally responsible for the feelings and ideas expressed in the work. Art and ethics are closely related in the real world; hence we cannot be indifferent to the behavioral consequences of what we make; that would imply insensitivity at best and irresponsibility at worst. Finally, the doctrine of art-as-art, aside from its circularity, ignores the fact that artworks are vehicles of meaning[20] as well as configurations of form. Since form and meaning arrive in the "same package," so to speak, artistic creations cannot be divorced from what they say without doing violence to the fundamental character of aesthetic perception.

At this point we need a definition of morality that can apply to everyone, regardless of age, education, trade, or status. For that purpose it would be hard to improve on Paul Tillich's words: "Morality, in the first place, is the experience of the moral imperative . . . A being without the consciousness of a moral demand is not human."[21] In equating the moral with the distinctively human, Tillich performs an important service for art educators; he enables us to ask this question: Is there any legitimate connection between art instruction and the development of a moral sense in the *potentially* human persons we teach?[22]

Here it should be stipulated that Tillich does not use "moral" in the narrow or, as he puts it, the "Anglo-Saxon" sense. Which is to say, he uses "morality" to mean more than sexual behavior. Tillich's reference is to Kant's categorical imperative, which he calls the "unconditional character of the 'ought-to-be.'"[23] Again, we have an expression that bears on our work: the artistic act is an act of commitment; to invest thought and energy in an image is to commit oneself completely; the character of that commitment is *unconditional* because, in Tillich's words, it involves "the law of our own being."[24] That law is felt as right because it comes from within;

20 And "meaning," according to Reichenbach is among other things a disposition to act.

21 See Tillich, Paul. *Theology of Culture,* p. 134.

22 The role of art in human potentiality is implied by the title of my book. (See Feldman, Edmund B. *Becoming Human Through Art.*)

23 *Ibid.,* p. 134.

24 *Ibid.,* p. 136.

thus the art act may represent our most authentic encounter with "the ought-to-be."

Art teachers learn quite early that there is an "ought" as well as an "is" in everything pupils make. We can go further: there is an "ought" in almost everything pupils *say* about what others have made; their speech is charged with normative import. In their critical talk especially, pupils seek moral exemplification, and usually they find it. Thus, the horses of Franz Marc are bright blue "because" those creatures are *good,* that is, they live as friends in harmonious relation with nature. Similarly, the cathedrals of Monet have purple shadows because that is how a church *should* look if it is rightly seen—with "should" understood as more than a chromatic truth: it is a moral affirmation. Which is to say, the color purple unites the building with its transcendent purpose.

For the innocent eye, at least, artistic decisions are ethical choices, and aesthetic qualities are moral imperatives. When a student displays his or her work it is a spiritual disclosure. In responding to that work we are involved in a moral situation: we are present as a soul *reveals* itself in what it believes to be its *essential goodness.*

THE MORAL IMAGINATION

Moral action implies moral choice. Philosophers may differ about the grounds of moral choice, but they agree that morally significant situations call for deliberation leading to decision.[25] Of course, law, conscience, a sense of duty, or spontaneous feeling can also direct our behavior, which may be honorable and decent; but decent behavior does not necessarily entail moral *choice.* Choice implies (1) involvement in a morally ambiguous situation; (2) the awareness of alternative courses of action; (3) the disposition to act or to avoid acting; (4) an effort to anticipate the consequences of one's actions; and (5) the ability to judge the value of those consequences. This process in its totality defines the moral imagination—the capacity and willingness to make judgements in the light of an "ought-to-be," a "could-be," and a "what-to-do."

Now works of art are often held up as exemplars of "ought-to-be," "could-be," and "what-to-do." They offer us images of feeling or action that we may choose or refuse to emulate. Thus, *mimesis* enters the picture: most of us believe (rightly in my view) that imitation is *the* great "engine of moral instruction." But we think this principle applies mainly to children in their responses to represented actions. Is that the case with older, more sophisticated, persons? And what about works of art that are not repre-

25 For an extended discussion of this topic, see Kaplan, Abraham. "The Ethics of Deliberation," *In Pursuit of Wisdom: The Scope of Philosophy,* pp. 330–336.

sentational or obviously referential? Can there be a distinctively *moral* response to a Mondrian or an Albers?

It would appear that the moral imagination operates differently, that is, more abstractly, as one advances in age and grows in experience. Let us say the Mondrian implicates a viewer's ability to measure lengths, compare shapes, discern size relations, and visualize processes that are not *literally* represented—processes like expansion, compression, resting, floating, advancing, receding, and so on. Now these processes (which are inferred by the viewer) do not exhibit moral quality in themselves. What we can say is that seeing them in context *implicates* the moral imagination: we have *opinions* about expansion and compression: we *care about* forms that are squeezed or stretched, held back or let loose. In making estimates of the rightness of an action or the goodness of its outcome *in life*, we engage in the same kinds of seeing, calculating and imagining that are employed in viewing a Mondrian. Not surprisingly, Mondrian thought of his art as a type of moral and spiritual activity.

Works of art created for practical purposes have moral significance, too; it is an error to think craft values are confined to physical utility. From an ethical standpoint a well-made pot can stand higher than a Pre-Raphaelite canvas, whose announced subject-matter may be quite misleading. An ostensibly moralizing work—say Rossetti's *The Awakening* or Gerome's *Roman Slave Market*—appears to me salacious rather than morally elevating. The so-called "applied arts," on the other hand, can function as exemplars of moral value even when that is not their intention. Consider the idea of purity in a chair by Mies van der Rohe, or the conviction of graphic honesty that emerges from a poster by Ivan Chermayeff. Moral concepts that have a forbiddingly abstract character in philosophic discourse acquire flesh and blood in art, and without our preaching!

The conventional wisdom is that great works of art offer a vision of the *ends* to which we may aspire. But morals and ethics are also concerned with *means;* indeed, Dewey has taught us that means are ends in themselves. Accordingly, we may ask whether an artistic method possesses moral significance. For those who teach art, the answer is clearly yes: artistic execution is a continuous process of devising and reflecting on technical means as in themselves "right" or "good." Especially in modern artistic practice, where the principal theme of a work may be the *way* it achieves form, it would be a mistake to think of technical means as ethically irrelevant. Technical choices are made in the light of real or imagined aesthetic effects which (despite strenuous artistic efforts to the contrary) always have ethical meaning. Let me offer a hypothetical illustration.

Suppose I am painting a man's portrait and want to show the change of plane from the brightly lit front of his face to the shadowy side of his head. To depict that change I can place a tone of yellow ochre next to a tone of burnt sienna and blend their common edge with my brush. Or I can

mix a special green on my palette and use it as a transitional tone.[26] Now this mixed transitional tone, I know from experience, is more interesting than a blend of yellow ochre and burnt sienna tones. It is "more interesting" because it is chromatically exciting, it represents a fresh way of modeling form, and it provides important information about the man and the circumstances in which I see him. That green lets me say he is lean, pale, and clean-shaven; it lets me tell the viewer that I think the man is thoughtful and, perhaps, somewhat ascetic. It enables me to say that I believe these are admirable qualities.

Is my "special" green merely a technical solution to the problem of managing changes in light, color, and volumetric condition? No, it is something more: that green tone constitutes an artist's way of making a moral statement; it is a solution to a painterly situation and a declaration about a particular person to whom certain qualities of character are attributed by the way his head is painted. To see a *particular* green, then, is to see more than green. My teacher, Abraham Kaplan, seemed to support this view when he said, "The recognition of moral quality may be as immediate and irresistible as sensory perception."[27] I would add that, under the right conditions and in the right context, sensory perceptions *become* moral perceptions. In other words, aesthetic quality and moral quality are like an old-fashioned marriage: it (they) cannot be torn asunder.

MORALITY INTERNALIZED

A morality taught by authority can be effective if it is unquestioned, if it operates with the force of law, or if it seems self-evidently right and good. But in a society like ours, where many moralities and moral exemplars thrive, an authorized morality is unlikely to gain general acceptance.

Authorized moralities face almost insuperable difficulties because ours is a multiethnic, multireligious society dominated by powerful media whose prosperity depends on celebrating the new—whether in manners, fashions, ideas, or morals. In the schools of such a society, the morality most likely to strike a responsive chord will be the third type mentioned— the morality that seems "self-evidently right and good" to students trying desperately to get in touch with their feelings. For such students a moral code is meaningful only if its content has been realized in, and validated by, their personal experience. Their ideas about what is right and good cannot be imposed from outside; their morality must be discovered within or created anew. Regardless of where their ethical ideas come from, students

26 For painters who may be interested, this green is made of raw umber, cadmium yellow, and white.

27 Kaplan, *op. cit.*, p. 330.

need to believe they build their *own* morality—at their own speed and of their own accord.

This is an anomalous situation, to be sure, but for us it may represent an opportunity: studying art is very well suited to the learning style of - today's students. However, the moral values we espouse will not "take" unless they are *internalized* through our students' art experience. *Our* morality can be learned only through what *they* do.

Accordingly, an art ethic (will all its implications for a life ethic) must rely on the experience of making, explaining, and judging art. Which seems obvious: we cannot teach morals except indirectly. And for our teaching to succeed, students must learn to imagine well. They must learn to "see" living options in their technical and aesthetic choices. As Shelley said, "A man to be greatly good must imagine intensely and comprehensively; he must put himself in the place of another and of many others; the pains and pleasures of his species must become his own. The great instrument of moral good is the imagination . . ."[28] The poet stated what philosophers mean when they say the moral life requires the capacity to make choices in the light of alternative ideas (I would say "images") of value. If there is such a thing as "moral literacy" it is acquired through the habit of ethical deliberation.

Can the "habit" of ethical deliberation be taught? If so, can it be taught as a skill? This would appear to be a question for professional ethicists. What art educators know from the experience of teaching is how to *stimulate* the imagination, how to *release* imaginative energy, and how to deal with the *reality* of imaginative life.

We have also learned to see creative expression as an authentic type of decision making. The beauty of art teaching, from an ethical standpoint, lies in the fact that it does not waste spiritual energy in neurotic symptom formation; it does not spend time rehearsing the tragicomedy of our *inde*cision. Making art requires real choice in the form of a real commitment to a real image in the process of becoming itself.

Seen in this light, an image cannot be reduced to a set of colored shapes resting on a flat surface, or a system of forms floating in three-dimensional space. For us the image represents a *set of decisions* made by a young person—decisions that were made after considering other options, decisions that involved rejecting other options, decisions that were allowed to stand and be seen, decisions through which that young persons was willing to be *judged*. That is what an internalized morality means: a willingness to be judged according to the goodness of the decisions one has made.

28 See Shelley, Percy Bysshe. *In Defense of Poetry* (1821).

MORALITY IN CRAFT

Apart from any philosophic or ethical justification, morality in art has a technical source: craft. It should be added that craft can also be understood in a bad sense as craftiness, or guile, or deceit. In other words, some artists and artisans choose to make things badly or dishonestly, and because of their cunning, they get away with it. Now, bad or dishonest craft is not only a matter of working with inferior materials, or exercising one's skills carelessly, or engaging in visual sleight-of-hand. Bad craft means making a dishonest artistic statement for someone else to believe, to possess, and to cherish.

Perhaps the most familiar form of bad or dishonest craft is deceptive appearance. At a deeper level, bad craft means saying skillfully what one does not believe; or saying with conviction what one knows to be harmful; or making a statement that conceals from viewers and users what we know is essential for the completeness of that statement. Now, the craftsman's ethic requires finish, the elimination of flaws or blemishes, and the fulfillment of a consumer's reasonable expectations. It also mean honesty, that is, full disclosure about the use of tools and materials.

I believe "full disclosure" is an aesthetic and ethical as well as a technical consideration: it is through "full disclosure" that crafts people declare their *integrity*—a word that means wholeness. Wholeness, in turn, is derived from the Anglo-Saxon word *hal,* meaning health. This etymology is no accident: the craft ethic is rooted in health—the health of creators and users alike.

If my analysis is correct, morality in craft extends beyond the making of objects to the well being of the persons who interact with those objects. The same principle applies to the morality of art: no matter how complex its creation or exalted its mission, art cannot lose its moorings in craft. For that reason, artists and art students cannot escape the morality of craft, nor should they wish to escape that morality.

Anthony Burgess puts our point well: "Art begins with craft, and there is no art until craft has been mastered. You can't create unless you're willing to subordinate the creative impulse to the construction of a form."[29] Perhaps "subordination of the creative impulse" sounds like heresy to art educators. But the phrase can also be understood as praise for the craft ethic: that ethic understands "creative" as the ability and willingness to solve another person's problems. As for "the constriction of a form," I think Burgess is really saying that crafts people cannot in good conscience ignore the *practical* determinants of form. Those "determinants," of course, are the needs of the people who use what we make.

A final thought about morality in craft. Work is (or should be) the ex-

29 See Burgess, Anthony. *But Do Blondes Prefer Gentlemen?* p. 101.

ercise of craft. Like craft, work has a purpose that transcends its physical utility and the expectation of pecuniary reward: work helps erase the tensions that always exist between human beings and the jobs they have to do. We need to learn—and why not through art?—that our subjective feelings and the world's objective requirements are joined in meaningful work. From that experience comes the discovery that satisfying a human need, no matter how small, constitutes a spiritual opportunity: good work represents our best chance to become reconciled to existence in the world. And that is a reward we did not expect when we first learned to sharpen our tools, clean our brushes, and put things away neatly.

MEDIA AND MORALS

Crayons, tempera paint, and modeling clay are feeble instruments of moral instruction compared to films and television and the flood of electronic images soon to arrive via "information superhighway." As for the transmission of moral values, we are painfully aware of the weakness of art teachers when confronting the power of the mass media; the traditional art forms have been overwhelmed by the latest communications technologies. Not surprisingly, many teachers see their professional salvation in those same technologies. After all, our inherited art forms began life as "new media." So, even if moral values were not involved, the new media would pose serious challenges to art teachers. Here we might ask how any medium—old or new—affects education and morals.

Consider an "old media" example: stained glass. As a new technology in A.D. 1140 (actually an old technology newly mobilized) stained glass had a profound effect on medieval morals and sensibility. Why? Not because it said something twelfth-century folk had not heard, but because it was inherently beautiful—fascinating to sense as well as to reason and intellect. In the twelfth century, stained glass changed the way people "saw" the light, experienced space, and understood the meaning of life, in the now and in the hereafter.

One lesson of stained glass is that a new medium is initially received as an aesthetic excitement: its effect is first to dazzle and then, perhaps, to instruct. In time, the aesthetic effect becomes a moral and ritual necessity; the sensuous excitement of a medium is infused with ethical, behavioral, and even spiritual significance as we "get used to it."

Let us consider a media example from Asian culture—brush-and-ink calligraphy. Today it seems hopelessly backward compared to writing with mechanical pens or modern keyboard instruments accessing information stored in computer memory banks. Yet, Chinese, Japanese, and Korean educators continue to teach calligraphy. They teach modern computer languages, too, but they are convinced of the moral and philosophic supe-

riority of their traditional ideographic forms executed with brush and ink. Is this a matter of nostalgia and resistance to technical change? Not really. For Asian pedagogues, calligraphic writing represents the best way to teach visual acuity, kinaesthetic control, and compositional judgment *at the same time*.[30] The practice of calligraphy gives Asian pupils certain physical, moral, and aesthetic benefits: muscular coordination, personal discipline, reverence for nature, and appreciation of the dynamics of visual form. Interestingly, these values are related to a religion, Confucianism, whose ethos is closely connected to writing and painting with the Chinese brush.

Apparently, moral education is linked to traditional media—stained glass, for example, or Chinese brush calligraphy. That impression is etymologically warranted: our word "moral" is derived from the Latin *mores,* which means "customs" or "manners" or "behavior." Our ways of learning about the world and how to act in the world rely on the media structures which have shaped that world. It would seem that moral behavior (which includes everything from Kant's categorical imperative to "situational ethics," to the plain decencies of everyday living) cannot be separated from our media of communication and expression.

Naturally, there is conflict and contradiction between the moralities expressed in the new media and the traditional media—between the behaviors encouraged by a rock concert and a Mozart concerto, a television soap opera and a Dickens serial novel. For those reared in, and accustomed to the old media, it appears that moral education struggles continually with Gresham's Law: as "cheaper" money becomes the prevailing medium of exchange, "expensive" money is driven out of circulation: art, manners, and morals exhibit less tact, subtlety, and intellectual rigor. An ethics-and-aesthetics based on traditional modes of art-making loses value as it is replaced by a new ethics-and-aesthetics based on easier modes of image production and consumption.

"Easier modes" suggests the following illustration: when we say a new computer is "user friendly," we mean less work is required of its operator because more work is done inside the computer. We also mean that the "operator" does a different *kind* of work; perhaps it is a "higher" kind of work and perhaps it is not. In any case, we encounter what I shall call "the Chinese brush dilemma." Are we willing to forego the physical and moral benefits of calligraphy in order to enjoy the economic benefits of computer technology? Apparently, Asian educators are determined to have both—by spending more hours and days in school. Which suggests they are

30 Herbert Read approvingly quotes the Chinese writer Lin Yutang: "So fundamental is the place of calligraphy in Chinese art *as a study of form and rhythm in the abstract* that we may say it has provided the Chinese people with a basic aesthetics . . ." (See Read, Herbert. *The Grass Roots of Art,* p. 116.)

unwilling to surrender real aesthetic goods in return for promised gains in cognitive efficiency.

We might return here to the question raised by Gresham's Law: Does it condemn art education to a steady moral deterioration? I think we must answer "yes," if the old media are completely and mindlessly replaced in schooling. But our answer would be "no," if the materials, techniques, and processes employed in teaching art are intelligently balanced. This rather simple answer to the question might be illustrated as follows.

During the oral or preliterate stage of most human cultures, special castes of men and boys were trained (usually by ritual chanting) to memorize and recite the chronicles and sagas of their tribes and clans. After years of memory training the members of these castes—the male members alone—"knew" the sacred stories; others merely heard them. Needless to say, the old bardic castes enjoyed a monopoly of knowledge of the past—a monopoly that enabled them to exercise great influence over the present.

Today, of course, almost everyone has instant access to the yarns and epics of all peoples via inexpensive and convenient memory devices—books, recordings, video cassettes, CD-ROM's, and so forth. Yet teachers still encourage their pupils (now including girls!) to memorize "Barbara Fritchie," the Preamble to the Constitution, Lincoln's Gettysburg Address, and so on. For a similar reason, school pupils memorize addition, subtraction, and multiplication facts *even though* hand-held computers can perform the same operations and "know the facts" for them. Clearly, teachers think memorization yields special moral, cognitive, and aesthetic dividends notwithstanding the time that could be saved with modern recording and calculating devices. Why? Perhaps teachers know how the saved time would be spent.

But even if the saved time were not squandered, we have other reasons to seek media balance in art curricula. First, there is the idea of education as the construction of character by going to the original sources of our morality, by getting in touch with our roots, and by learning what the past can teach us. This is what we mean by a "classical" education; its principal aim was preparation for leadership or enlightened citizenship through *bildung,* the formation of character. An art educator would say that character is something we build *through a medium*— the medium of the self-working with the materials given to us by nature, technology, and history. The traditional media never lose their character-building utility—even when they employ old materials and "out-of-date" skills.

Second, every old medium makes a statement about every new medium—which greatly enriches learning about art and learning about life. Painting says something about photography, clay modeling says something about engineering, and printmaking says something about computer graphics. Third, we can probably gain a better understanding of the languages of film, television, and advertising graphics if we have tried to draw a comic

strip (or if we have tried to figure out a Peruvian textile, an Egyptian hiero-glyph, or an Aztec mural). In other words, the media *explain* each other as they build on each other. Media interactions create new aesthetic facts; from those facts important cognitive and moral consequences flow.

Considered together, the media set the parameters of a people's moral striving. It is not correct to see the media merely as arenas where moral or immoral actions are vividly represented; the media *embody* moral mean-ings in their formal structures. As educators, however, we cannot "get at" those meanings without understanding how their forms work. Because they have their own agendas, we need to empower ourselves vis-à-vis the media-meisters. Which means that we need to understand what they say and how they say it. What better place to start than with the media we al-ready know? What better way to study media than through art? What bet-ter time to begin than now?

CONCLUSION

The following statements attempt to summarize and resolve this chapter's main arguments about cognition and morals as these topics bear on the philosophy of art education.

Art education has a *cognitive* dimension because teaching and mak-ing art proceed from a *knowledge* base. Art education has a *moral* dimen-sion because teaching and making art proceed from an *ethical* base. Schooling is conducted on the assumption that the knowledge base and the ethical base *interact*. In practice this does not occur often enough: art teachers are prone to swing from one base to the other, with ethical con-siderations understood as inhibiting expressive purposes. Or we build a knowledge base so obsessively that art's expressiveness is lost in the course of displaying *know-how* competence and *know-that* information. This is unfortunate because the enterprise of schooling looks to us for a model of *moral-and-cognitive* integration. If we cannot demonstrate the how, what, and why of learning *in a single package*, then we disappoint the best hopes of our friends and supporters.

Knowing through seeing is a serious mode of cognition and a valid way of learning about reality. Our challenge is to *use seeing* wisely in teach-ing art. Dewey's discussion of knowledge through seeing, which he called the "spectator conception of knowledge," was directed against knowing as *beholding,* with "beholding" understood as "dwelling contentedly on the images of things." To his way of thinking, the processes of change are "veiled from perception."[31] Dewey conceived of seeing as largely *external* and *contemplative,* but he granted that artistic seeing might be different in-

31 See Dewey, John. *Reconstruction in Philosophy,* pp. 99–103.

sofar as it *changes* what is seen. "Chang(ing) what is seen" calls attention to our cognitive ambition: we want to generate knowledge by using our eyes as a probe, not a mirror.

Artistic seeing is an active process that contemplates the *transformation* of what is optically registered. When artists look at things, it is with a view toward changing them *phenomenally* so they will appear to others as what they are, or could be, or should not be. To observe the *quiddity* of things is not to accept surface appearances passively, although, as Kaplan says, "What lays claim to account for reality must first of all account for appearances."[32] Nor do we tell lies when we record an appearance; good artists are far more than skilled reality imitators or clever "nature fakers." They are more like astronomers who try to *explain* phenomena by "making sense" of the light energy sent in their direction by distant objects.

It must be obvious that *knowledge* has an existence apart from words. For art educators, a pupil's landscape painting represents a piece of embodied knowledge—of the land, sky, waters, vegetation, and so on of a particular place. That place might or might not be real in the geological sense. However, such "reality" as the painting possesses, and such "knowledge" as that reality designates, is infused with moral as well as cognitive value. That is, the landscape elements were chosen, organized, and depicted in the light of an *appears-to-be*, an *ought-to-be*, a *could-be*, or perhaps a *should-not-be*. For the youthful landscape artist it was impossible to separate cognitive discoveries from aesthetic intentions, or technical possibilities from moral choices. The reality, truth, and goodness of the picture are all-of-a-piece, for the artist and for us who view the artwork.

Art *media* have no moral significance in themselves; the newness or oldness of an information-and-communications technology says nothing about its intrinsic goodness or badness. However, all media acquire *moral connotations* as people use them to express feelings, share ideas, and facilitate their social interaction. The process of *learning to use* an art medium is infused with the meanings traditionally associated with that medium *because* media form-and-content cannot be separated in artistic creation or aesthetic experience. In the case of traditional media, moral meanings have had time to accumulate and reinforce each other. In the case of new media, moral meanings tend to be overwhelmed by fresh aesthetic excitements. The challenge to art educators is to find the *right curricular mix* of old and new media for their students, at a particular point in *their* personal development, and at a certain moment in *their* consciousness of history.

How can art educators (who know little of neuroanatomy, biochemistry, or molecular biology) cope with the lofty concept of *cognition?* Neurologists think it is a function of the *brain;* psychologists consider it a function of *brain-and-body.* Philosophers tend to treat it as a property of

32 Kaplan, Abraham. *Ibid.*, p. 169.

mind. It would be best for art people to heed the philosophers. The concept of mind best suits our needs: it accepts the intelligence of our hands and eyes, it has room for emotion, it is hospitable to the idea of experience, it is open to the influence of culture, it can make sense out of aesthetics, and it does not restrict artistic thinking to a special patch of the brain.[33] If we must name the site where cognition-through-art occurs, "mind" would appear to be right.

Art education approaches the *problem of evil* sideways, by stressing the utility of the *moral imagination* in the process of *ethical deliberation.* As for evil itself—the evil impulse—it has a visual character for art educators. Every artistic image represents a *plan of action* which encourages (or discourages) the images within us that exist as *dispositions to act* creatively or destructively. Strictly speaking, evil does not reside in the work of art, no matter how repulsive. Evil has to be *actualized* by a *conjunction of images*—the image in the artwork reaching out and joining the image within us that finds cruelty attractive.

The attractiveness, or aesthetic appeal, of cruel imagery should not be underestimated: it accounts for the power of Expressionist art; it explains the creativity of artists such as Picasso and DeKooning; and (painful to acknowledge) it satisfies a real need of our human nature. That need often expresses itself in the art of children and adults, including the masters. But there is an answer to the destructive impulse in art and in ourselves: it is the creative or productive impulse. It arises from our desire to fashion an image that reflects the love we have received. That productive impulse is weak at first, but it can grow: it grows especially with good teaching.

REFERENCES

AIKEN, HENRY DAVID. *Reason and Conduct.* New York: Knopf, 1962.

BELLOW, SAUL. "Love, Art and Identity," *The New York Times,* June 3, 1987.

BENNETT, WILLIAM J. "Moral Education in the Schools," *The Public Interest,* no. 50, Winter 1978.

BILLINGS, JOSH. *Encyclopaedia of Wit and Wisdom,* 1874.

BROUDY, HARRY S. "The Structure of Knowledge in the Arts," in Stanley Elam, ed. *Education and the Structure of Knowledge.* Chicago: Rand McNally, 1964.

BRUNER, JEROME. *Actual Minds, Possible Worlds.* Cambridge, MA: Harvard University Press, 1986.

33 The notion of art as a product of "right-brain thinking" seems *mindless* if we consider Leonardo's career. Which half of his brain did he use when drawing an embryo in the womb, designing a flying machine, or making drawings for a domed church? Did he cease to be an artist when he engaged in this "seeing" and thinking? Did he attend to these varied phenomena as anonymous pieces of stuff defined by negative space? I think he exploited every resource he had.

BUBER, MARTIN. "The Education of Character" (1939), *Between Man and Man.* Boston: Beacon Press, 1955.

BUBER, MARTIN. "Productivity and Existence," *Pointing the Way.* New York: Harper and Brothers, 1957.

BURGESS, ANTHONY. *But Do Blondes Prefer Gentlemen?* New York: McGraw-Hill, 1986.

CASSIRER, ERNST. *An Essay on Man.* New Haven: Yale University Press, 1944.

CROCE, BENEDETTO. *Aesthetic,* Douglas-Ainslie (trans.). New York: Macmillan, 1909.

DEWEY, JOHN. *Art as Experience.* New York: Minton, Balch, 1934.

DEWEY, JOHN. *Reconstruction in Philosophy.* New York: Mentor Books, 1948.

DILLIARD, ANNIE, "Is Art All There Is?" *Harper's Magazine,* August, 1980.

EDMAN, IRWIN. *Arts and the Man.* New York: Mentor Books, 1949.

EDWARDS, BETTY. *Drawing on the Right Side of the Brain.* Los Angeles: J. P. Tarcher, 1979.

EISNER, ELLIOT W. *The Educational Imagination,* 2nd ed. New York: Macmillan, 1985.

FELDMAN, EDMUND B. *Becoming Human Through Art.* Englewood Cliffs, NJ: Prentice Hall, 1971.

FELDMAN, EDMUND B. *Practical Art Criticism.* Englewood Cliffs, NJ: Prentice Hall, 1993.

HAUSER, ARNOLD. *The Philosophy of Art History.* New York: Knopf, 1959.

HOFSTADTER, ALBERT. *Truth and Art.* New York: Columbia University Press, 1965.

HUSSERL, EDMUND. *Phenomenology and the Crisis of Philosophy.* New York: Harper & Row, 1965.

KAELIN, E. F. *An Aesthetics for Art Educators.* New York: Teachers College Press, 1989.

KAPLAN, ABRAHAM. *The Conduct of Inquiry.* San Francisco: Chandler, 1964.

KAPLAN, ABRAHAM. *In Pursuit of Wisdom: The Scope of Philosophy.* New York: University Press of America, 1977.

LANGER, SUZANNE K. *Problems of Art.* New York: Scribner's, 1957.

LIPPMANN, WALTER. *A Preface to Morals.* New York: Macmillan, 1929.

McLUHAN, MARSHALL. *Understanding Media: The Extensions of Man.* New York: McGraw-Hill, 1966.

MINSKY, MARVIN. *The Society of Mind.* New York: Simon & Schuster, 1987.

MURDOCH, IRIS. *The Fire and the Sun: Why Plato Banished the Artists.* New York: Oxford University Press, 1991.

PEPPER, STEPHEN C. *The Basis of Criticism in the Arts.* Cambridge, MA: Harvard University Press, 1949.

PERKINS, DAVID N. "Art as an Occasion of Intelligence." *Educational Leadership,* January, 1988.

POGGIOLI, RENATO. *The Theory of the Avant-Garde.* Cambridge, MA: Harvard University Press, 1968.

POLANYI, MICHAEL. *The Tacit Dimension.* Garden City, NY: Doubleday Anchor, 1967.

READ, HERBERT. *The Grass Roots of Art.* London: Lindsay Drummond, 1947.

REICHENBACH, HANS. *The Rise of Scientific Philosophy.* Berkeley and Los Angeles: University of California Press, 1951.

REIMER, BENNETT. *A Philosophy of Music Education*. Englewood Cliffs, NJ: Prentice Hall, 1970.

RYLE, GILBERT. *The Concept of Mind*. London: Barnes and Noble, 1949.

SCHWEITZER, ALBERT. *Civilization and Ethics*, 3rd ed. London: Adam & Charles Black, 1946.

SHELLEY, PERCY BYSSHE. *In Defense of Poetry*, 1821.

SORRI, MARI. "The Body Has Reasons: Tacit Knowing in Thinking and Making," *Journal of Aesthetic Education*, vol. 28, no. 2, Summer, 1994.

STEINKRAUS, WARREN E. *Philosophy of Art*. London: Collier Macmillan, 1974.

TILLICH, PAUL. *Theology of Culture*. New York: Oxford University Press, 1959.

TREFIL, JAMES. *Smithsonian Magazine* (letter to). January 1994, vol. 24, no. 10, p. 14.

TRILLING, LIONEL. *Sincerity and Authenticity*. Cambridge, MA: Harvard University Press, 1972.

WHITEHEAD, ALFRED NORTH. *The Aims of Education*. New York: Mentor Books, 1949.

WILSON, JAMES Z. "What Is Moral, and How Do We Know It?" *Commentary*, June 1993.

AFTERWORD

The reader who has come this far knows that I have not written "the" philosophy of art education—which is as it should be. Our profession would be no more than a trade if all its practitioners thought and acted alike. I have tried mainly to raise the questions and ventilate the issues which I believe art teachers ought to care about. Beyond that, I have attempted to enhance the dignity of art teaching by relating its practices and concerns to some of the main problems of philosophy. Needless to say, my craftsmanship as a philosopher leaves much to be desired: if any "real" philosophers run across this material, I hope they will be kind.

Attentive readers have probably recognized places where opinions crept into the text. Usually, the context shows whether I was expressing a common understanding, my "sense of the meeting" as the Quakers say, or speaking for myself alone. Experienced art teachers will know the difference. As for art students, they will not be led astray; in my experience they feel free to "think otherwise." That sounds like another opinion, or at least a broad generalization, but I assure the reader it is based on long observation of artistic flora and fauna.

For having the gall (or chutzpah) to write this book, I offer the following excuse. I was confused when I began to teach art and I think it was

because I knew something about drawing, painting, color, and composition, not to mention the history of art, but had not a clue as to why any young person would or should care about what I knew. As for the litany of art educational objectives that I once had to learn, it seemed to me they ranged from noble and generous to philosophically inadequate to just plain wrong—well meaning but wrong.

So I *had* to write this book. The exercise will not have been in vain if other art teachers (we have heard enough from nonart teachers) are encouraged by this effort to add their bit to our collective wisdom. Consider one possible dividend: If teachers reflect on the reasons why they teach art, artists may reflect on the reasons why they make it.

INDEX

A

Acculturation, 20
Added value in economics, 24, 29, 41
Advertising or demand creation, 31, 41
Aesthetic appreciation, 41
Aesthetic literacy, 72–73, 91
Aesthetic quality, 24, 42
Aesthetics of consumption, 27–29
Aesthetics of production, 26–27
Age grouping, 8–9
 "school art style," 8
 simplicity of expression, 8
Anthropological dimension of art education, 10, 21
Appearance design, 31, 41
Architectural form, 18, 22
Art:
 defining trait of, 5

life of a community, 7
and morals, 107–9
and truth, 98–99
Art ability, 76, 91
Art activism, 59–61
Art-consuming institution, 6
Art criticism in classroom, 51
Art education, 1
 aged, retired, senior citizens, 8
 life–long learning, 8
 sources for life-long learning, 8
 definition of, 2
 problems encountered, 6
Art educational leadership, 53–56, 64–65
 See also Leadership
Art education policy, 56–59
 See also Policy
Art-for-the-aged group, 8
Art history, 21

power, 47–49
public opinion, 51–53
public support, 61–62
Political power, 47–48, 64
Politics, limits of, 62–64
Popular art, 65
Power of art education, 47–49
Power of images, 48
Power of selected works, 48
Process of communication, 27
Product aesthetics, 41
Propaganda artes, 64
Propositional knowledge, 100–101
Psychological dimension, 68–69
 child-art aesthetic, 80–82
 creativity, 86–89
 critical thinking, 78–80
 imitation, 73–75
 motives and motivation, 76–78
 "outsider" art, 84–86
 perception, 71–73
 perceptual outcomes, 75–76
 personality and talent, 82–84
 sensation, 69–71
 therapeutic idea, 89–90
Psychological potency of visual im-
 ages, 47–48, 64, 75
Psychological-type, 83, 91
Public opinion, 51–53, 64
Public support, 61–62

Q

Quality in art, 24, 41
Quality of learning, 65
Quiddity knowledge, 103–4, 118

R

Race and ethnicity in social dimen-
 sion, 10
 multicultural ideology, 10
 promoting pride and self-esteem, 10
Religion in social dimension, 11–12
 artistic and aesthetic occasions, 12

connection between visual forms
 and values, 12
descriptive versus prescriptive,
 11
holiday-art curriculum, 11–12
introduction to religious iconogra-
 phy, 12
religionists versus humanists,
 11
Representational truth, 99

S

"School art style," 8
Seeing:
 ability to see visual forms,
 76
 artistic, 118
 discipline of, 70–71
 knowledge through, 117
 perceptual outcomes, 75
Self-expression in art, 5–6, 91
Sensation, 69–71, 90–91
 distinction between perceptions
 and, 71
Sex and gender in social dimension,
 12–13
 art education and, 12
 feminine role and art education,
 12–13
Simplicity of expression, 8
Social act, 20
Social-aesthetic competence, 22
Social changes in social dimension,
 13–15, 21
 art education as agent, 13
 art teachers transformation contri-
 bution, 13–14
 evolutionary change, 14–15
 plasticity of all structures, 14
 visual change and art education,
 14
Social dimension of art teaching,
 5–6
 age grouping, 8–9
 class phenomena, 9–10